A Gullah Guide
to Charleston

A Gullah Guide
to Charleston

Walking Through Black History

Alphonso Brown

THE
History
PRESS

Published by The History Press
Charleston, SC 29403
www.historypress.net

Copyright © 2008 by Alphonso Brown
All rights reserved

Cover art: (front) Detail from *Jubilation* by Mary Whyte, (back) *Tending* by Mary
Whyte. Both paintings are courtesy of Coleman Fine Art. Please visit www.
colemanfineart.com for more information.

First published 2008
Second printing 2009
Third printing 2010
Fourth printing 2011
Fifth printing 2012
Sixth printing 2013

Manufactured in the United States

ISBN 978.1.59629.392.2

Library of Congress Cataloging-in-Publication Data
Brown, Alphonso.
A Gullah guide to Charleston / Alphonso Brown.
p. cm.
ISBN 978-1-59629-392-2
1. Charleston (S.C.)--Guidebooks. 2. African Americans--South Carolina-
-Charleston--History--Anecdotes. 3. Gullahs--South Carolina--Charleston-
-History--Anecdotes. 4. African Americans--South Carolina--Charleston--
Biography--Anecdotes. 5. Gullahs--South Carolina--Charleston--Biography-
-Anecdotes. 6. Historic sites--South Carolina--Charleston--Guidebooks. 7.
Historic buildings--South Carolina--Charleston--Guidebooks. 8. Charleston
(S.C.)--Buildings, structures, etc.--Guidebooks. 9. Charleston (S.C.)--History--
Anecdotes. 10. Charleston (S.C.)--Biography.--Guidebooks. I. Title.
F279.C43B76 2008
975.7'91500496073--dc22
2008007848

CONTENTS

ACKNOWLEDGEMENTS

How can one forget the breakfast table discussions at Mount Zion AME Church at 5 Glebe Street following the 7:30 a.m. services? I can still hear the late Sarah Findley Dowling saying, "Oh God boy, please! We can say 'Calhoun,' we mean to say 'Killhoun'!" On another subject, the late Pauline Graves would tell the story of how, during the civil rights movement, Reverend Rip Lemon washed his clothes in the "whites only" section of the laundromat. When confronted by the owner, he said, "Doesn't that sign say *whites only*? Well, I am doing my white clothes. Over there under the colored sign are my colored clothes." Thelma Sumpter kept everyone abreast on what was happening in the AME Church. Her husband, Reverend B.F. Sumpter was a minister at Mount Zion and an elder in the church. The late Julia Pope brought me books and more books of old Charleston. The late Moses Moultrie, who tried to compete with the rapid tongues of the ladies, would finally get a word in edgewise. He said, "We didn't call that thing Paddy Wagon or Black

Maria, we call it Black Lucy." Tons of information was discussed at the table and sometimes I couldn't finish my breakfast for trying to write everything down. The entire Mount Zion Church family was very supportive and gave out information at a whim.

I needed a course in shorthand when listening to Felder Hutchison. Mr. Hutchison is a walking Charleston encyclopedia—that's what I call him. Josephine Smith Cannon, a great friend, co-worker and typist, held a big stick over my head demanding, "Write, write, write and never stop." She was serious!

It pays to have English majors as friends. My sister-in-law Sandra Goodwin Harrison and her friend (and my friend) Emma Johnson are "proofreader perfectionists!" Even closer to home is my son, Reverend Howard Brown, who graduated from Clemson University with a degree in English. Whenever I needed something proofread, I would call him and tell him, "It's payback time!" My son Terrence loves to sing, so I often put on some of his music to keep me inspired. My son Joel would admonish me about what I could and could not write. Thank God they are all married and out of my house! My wife LaQuines would bring them back if she could, but I keep her busy proofreading.

My uncle Teet, whose real name is Reverend George Welch Brown, deserves a whole paragraph all to himself. He was my uncle, mentor, advisor, historian and, most of all, my *friend*. We would talk for hours about family history.

He was a man who was very knowledgeable about people and his environment. The man had a sixth sense! I have the same sixth sense. We got this from his mother, and my grandmother, Phyllis Steplight Brown. My next book will be about stories he shared with me. Thank God he wasn't a fast talker and I was able to write down everything he said.

This book is dedicated to the memory of my Uncle Teet, who died on January 25, 2008, at the age of eighty-five.

GULLAH HISTORY

Gullah is an English-based, creolized language that naturally evolved from the unique circumstances of, and was spoken by, the slaves in South Carolina and Georgia. It is not a written language. It is sometimes referred to as the patios of the Lowcountry. Along with many of the African and English words and expressions, it also contains some other foreign languages, or whatever could be picked up, depending on the nationality of the slave owner. The word *Gullah* is believed to be a mispronunciation of the African word *Gora* or *Gola*, which were names of tribes living in Sierra Leone, West Africa. The Vai people, or Gala, or Gallinas, are believed to be the African connection for the Gullah people in the Sea Islands. These Africans brought with them skills in science, construction, agriculture, animal farming, teaching and many other areas. They had over ten thousand years of experience in many of the developed civilizations in the world.

The South Carolina and Georgia Sea Island coast has many isolated islands that were inhabited by blacks long before, and following, the Civil War. The dual residency of some slave owners and the isolation that existed, especially after the Civil War, contributed to the proliferation not only of the language, but also of the African culture and traditions of the slaves. Their ancestors still practice (in some rural areas) the tradition of placing topsy-turvy medicine bottles or pills on the graves of the deceased. The old tradition of covering the mirror in a room after a loved one dies is still observed by many. This is to keep the deceased's image from reflecting in the mirror and causing it to spot. The yard swept clean will keep snakes away. Holding one's breath when passing a graveyard will not disturb the dead. Digging a grave north–south means the person died after having been "fix"—a victim of voodoo, witchcraft, a hex. It is believed that the spirit cannot rest turned crossways and will always haunt the unknown assailant, who will usually die in less than a week. The homemade long-handled hoes were not only used for reach in the fields, but also for killing snakes. The ceilings of the porches are painted blue to ward off evil spirits and also keep the bugs away. And the list goes on.

The practice of "root" medicine is still used by many blacks and some whites today. Benin, West Africa, is still known for its traditions of root medicine and witchcraft. Root medicine was used for both good and bad—evil and

greed made it more bad than good. Except for the few white doctors, who would secretly help slaves before and after freedom, the only medical help available to blacks in the New World was the people who knew the art of root medicine. These individuals who used their knowledge for good were not feared, and today they would be referred to as "herbalists."

Charleston and Beaufort, because of their many islands, form the nucleus of the Gullah-speaking area. Not until after the turn of the twentieth century, when many bridges were built connecting islands to the mainland, did blacks begin to move about and experience other areas. Much of their culture and many of their traditions have changed over time and many of the local blacks will tell you that "it was for the good." What outsiders call "culture and tradition" was considered hard and oppressive work. The black farmers would have loved to have had a tractor rather than walk behind a foul-smelling horse or mule all day. Instead of the old well pump, they would have preferred running water or indoor plumbing facilities and not having to fight the snakes for the outhouse.

It has never been the objective of the Gullah people to maintain this language. They never knew it was a language. It was thought of as "bad English," and they hated the ridicule that was associated with it. They had to communicate. There was always a concerted effort to speak English. There are no "th" sounds in most African languages, and many blacks, even today, have difficulty

pronouncing words like *this*, *that*, *these*, *them* and *they*. *Dis*, *dat*, *dees*, *dem* and *dey* are much easier.

Many linguists who came to the Lowcountry to study the language never gained the confidence and trust of the people and were met with rejection. Many left with little information and poorly guessed at conclusions. Lorenzo Dow Turner, a black linguist, was one of the few who were successful at documenting a very accurate account of the Gullah people and language. Being black, he had no problems relating to the people. He lived among them while doing his research.

Presently, in the classrooms, Gullah is acknowledged as a language that was spoken by Lowcountry blacks. There were a few efforts promoting its inclusion in the curriculum, but they were always rejected. A watered-down version is still privately used among friends and acquaintances, but it is certainly not the same pure and original sound of the Southern, rural, black 1920s.

Walking Tours

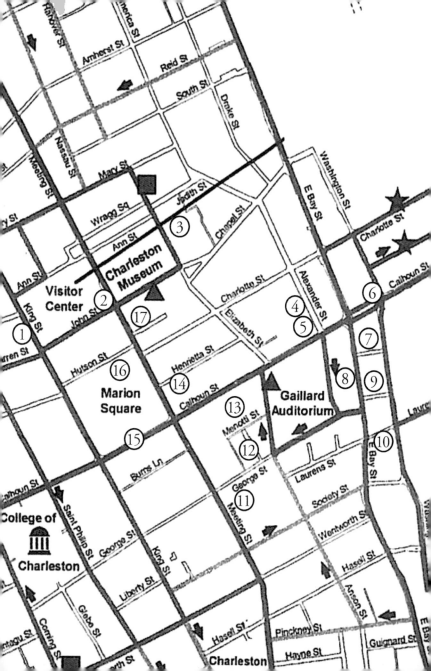

THE MUSEUM DISTRICT

1. KING STREET

Businesses Once Owned by Blacks

Dees some ob de black bidnis wha' bin on King Skreet.

Een eighteen ny'ty, Rufus Felduh open up 'e Baa'buh shop yah at shree hunnud fo' King Skreet 'n had twelb chair.

Een eighteen nynie six, Wainwright staa't up 'e print'n shop yah at six tirty shree King Skreet.

Een eighteen nytie ny'n, Attuh L. Macbet' open 'e pit'uh tekin' bidnes' at fy'b twentie nine King Skreet.

Een nyteen hunnud, Dash open 'e Dash Babbuh shop yah at fo' sebbinty one King Skreet.

Een nyteen ten, J.P. Seabrook 'n 'e wife Phe'by open uh shoe sto' 'n ressurunt at fo' hunnud forty one 'n fo' forty shree King Skreet. Deh say 'e bin de laahgis black-op'ratid shoe sto' een Amerike.

Een nyteen thirteen, Frydy open up 'e Baa'buh shop bidness' at sebbinteen King Skreet.

Een nyteen twentie eight, de Chaa'stun Mewshul Saybins bin open yah at fy'b forty two King Skreet. Also, een nyteen nyteen at two eighteen St. Fulup bin de People Feddrul Bank.

Een nyteen twentie, Jaspuh Simm open up 'e sweet shop at fo' hunnud twentie shree King Skreet.

Een nyteen twentie two, Damon Tommus, Seenyah, 'stablish de Lincoln Taytuh at six hunnud one King Skreet. 'E bin un major 'tractshun fuh cullud people 'til 'e clos' een nyteen sebinty. Tommus bin fum New Orleans 'n b'fo' moobin' tuh Chaa'stun, bin all obbuh de world staa'tn up 'e wanduwil' rebeu.

Een nyteen hunnud twentie fo', DeWees staa't 'e newsstand at de cornuh ob King 'n Radcliff Skreet.

Een nyteen twentie fy'b Macbet' open 'e dry-cleanin' bidness' at fy'b sebinty sebbin King Skreet.

In 1890, Rufus E. Felder opened his Felder Palace Barbershop business at 294 King Street and had twelve chairs. Rufus Felder was also the founder of Nehemiah Lodge #51, Free and Accepted Masons (F&AM), and served as their first worship master.

In 1896, Wainwright opened his printing shop at 633 King Street.

In 1899, Arthur L. Macbeth opened a photography studio at 529 King Street.

In 1900, Dash opened the Dash Barber Shop at 471 King Street.

In 1910, John Perry Seabrook and his wife Phoebe opened a shoe store and restaurant at 441 and 443 King Street. The shoe store was described as the largest black-operated shoe store in America.

In 1913, Friday opened his barber shop business at 17 King Street.

In 1915, the Seabrook brothers opened the Seabrook Hotel at 554 ½ King Street. George Seabrook was the proprietor.

Seabrook Shoe Store. *Courtesy of Thelma Sumpter.*

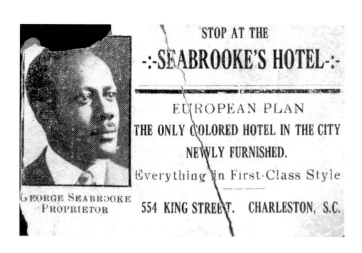

Seabrook Brothers Hotel. *Courtesy of Avery Research Center.*

In 1920, Jasper Simms opened a sweet shop at 423 King Street.

In 1922, Damon Thomas Sr. established the Lincoln Theater at 601 King Street, a major attraction for blacks until it closed in the 1970s. Thomas was from New Orleans and before moving to Charleston he had traveled all over the world promoting vaudeville reviews.

In 1924, DeWees started a newsstand at the corner of King and Radcliff Streets.

In 1925, Macbeth opened a dry cleaning business at 577 King Street.

In 1928, the Charleston Mutual Savings was opened at 542 King Street. Also in 1919, at 218 St. Philip Street was the Peoples Federal.

2. 375 MEETING STREET

Philip Simmons Gate

Fullup Summuns, duh kno' all obbuh de worl' fuh 'e bootiful gate 'n tings. 'E hab obbuh five hunnud ob dem gate on dem hous', 'n een dem meu'sm place. Deh call dis gate, de gateway tuh de city. De

cur'b ob de iron een de top ob de gate mean de wayb' rollin' een de ochun. Up deh een de uppuh 'n de lower middle paa't duh de look ob de fish. Dat mean de people all dem duh Christian 'n dey hab pleeny ob church fuh go tuh. Den dey say too dat de fish mean dey like fuh go fish'n. Dis gate yah 'zyn by Fullup Simmons 'n for'g by 'e cousin, Joesup Pringle.

Philip Simmons, an internationally known blacksmith/ ornamental iron gatemaker, has over five hundred documented gates and ironworks on homes and in museums all over America. This gate at the Charleston Visitor's Center represents the gateway to the city. The design of the scrolls in the upper part of the gate represents the rolling of the waves of the ocean into Charleston's harbor. In the upper and lower middle section of the gate is the symbol of the fish. The fish is symbolic of Christianity. Charleston is known as the "Holy City," where one may find an abundance of churches and denominations. Another explanation of the fish in the gate is that Charleston is a seaport town and is known for sport fishing. The gate was designed by Philip Simmons and forged by his first cousin, Joseph Pringle.

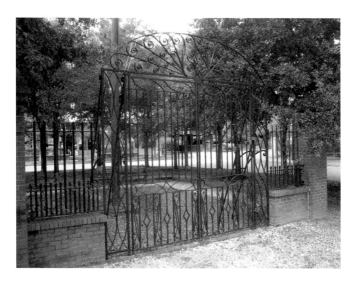

Charleston Visitors Center gate.

3. 48 ELIZABETH STREET

The Aiken-Rhett House

Gham by 'e pah wen 'e dead, Gub'nuh Aiken open up 'e house yuh plenny uh time fuh mek um big'uh. Dem slabe shanti still deh dey een de back yaa'd obbuh de haws' ban' 'n de kitch'n. Een no slabe bin lib yuh since aftuh de Whah when deh bin restruct'n we. Now de slabe hous' wah deh yuh now, duh cos' so much money dat dis dem million'nay people kin pay fuh lib' een burruh.

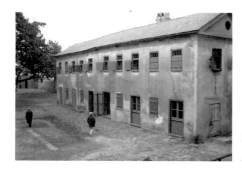

Slave quarters at
Aiken-Rhett House.

Inherited from his father in 1831, Governor William Aiken enlarged this house (originally built as a single house) several times to its present grandeur. In the backyard on one side are the original slaves' dwellings above the stable house and on the other side is the kitchen with six rooms of slave quarters upstairs. The slaves' quarters (often referred to as servants' quarters or dependencies) are the only known urban quarters that are still in their original and unlived-in state since Reconstruction. It is one of the finest examples of slave urban living in the city. Many of the slave dwellings in the city are now private homes that sell from around $100,000 and up.

4. 67 ALEXANDER STREET

Built By Richard Edward Dereef

Richud Edwud Dereef, one uh Chaa'stun richess free black man, bin een de wood bidnes', de house rent'n bidnes', 'n had uh dock tuh de end ob Chap'l skreet. 'E bil' dis yuh leetle two story hous' laytuh aftuh 'e buy de land een 1838. Dis bin uh big piece off'uh land reachin' way back tuh Killhoun skreet weh Dereef pit up six ah sebbin house. Dis duh de only one leff'. 'E lib right obbuh dey on Wash'ton Skreet. Latuh ron deh de call dah place "Rottonboro, Souse Khalina" cus' de people dey bin so bad. At one time Dereef own sixteen slabe, wah bin' plenny fuh uh rich white man.

Richard Edward Dereef, one of Charleston's wealthiest free blacks, was a wood factor, a real estate investor and owner of a wharf at the foot of Chapel Street. He built this small, two-story, frame single house sometime after he purchased the site in April 1838. The site was part of a large lot, extending to Calhoun Street, on which Dereef erected several buildings. Only this house remains.

Dereef built this house in the style of a single home. In Charleston, there are three main styles of houses. We have the single house, the freedman-style house and the double house. The single house is one room wide, long and is built sideways to the street. This is to maximize outdoor living space and to enhance ventilation in the hot weather. The

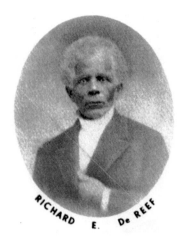

Richard Edward Dereef.

freedman's house, a style that was built by free black men, is just like the single house but only one story. The double house is two rooms wide, faces the street at full length and has a central entrance.

Dereef's residence was nearby on Washington Street. As late as the early 1970s, the area around Washington Street was known for its violence and criminal activities. It was commonly referred to as, "Rottenboro, South Carolina." At one time, Dereef owned sixteen slaves, which was a lot for even a rich white slave owner. Dereef was exempt from paying the "freedman's tax" because he claimed Native American descent. His mother Nancy Dereef was a descendant of a free American Indian woman.

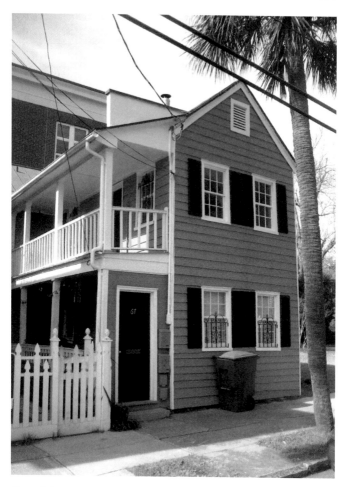

One of six rental units built by Richard Edward Dereef.

5. 65 ALEXANDER STREET

"Harp Of David" Gate by Philip Simmons

De 'lid'jus khaa'rectuh ob dis gate repuhzent de feelin' ob Mistuh 'n Mis Ahmstead Harrison who lib yuh den. 'Fo dat 'e bin de home ob Anna Banks wah help staa't McClennan /Bank Hos'bittle. Mistuh Harrison paah bin Fadduh Chaa'ls Harrison, one ob de Rectuh ob St. Maa'k 'Piscabal Chu'ch. De gate bin fix yuh 'wrung 1960. De gate bin zine by Fullup Simmons. Look how de end ob dem scroll duh curl een tight. 'E curl 'em likkuh dem gate mekuh bin do yuh obbuh two hunnud od yea'. 'E say, "Ef yuh shum curl een tight, uh mek um or 'e bin mek by dem great gate mekuh wah lib yuh way back yonduh."

The religious character of this gate, designed and forged by Philip Simmons, represented the personality of Mr. and Mrs. Armstead Harrison, who at that time were the owners of the house. Armstead Harrison's father, Father Charles A. Harrison, was a rector of Saint Mark Episcopal Church. The gate was commissioned around 1960. The scrolls of this gate, like all of Simmons's gates, are tightly curled on the ends. This is a style that was used by many of the great gate makers around the world. Simmons once remarked, "If you see the ends curled in tight, I made it or it was made some two hundred years ago by some great gate makers here in America." The

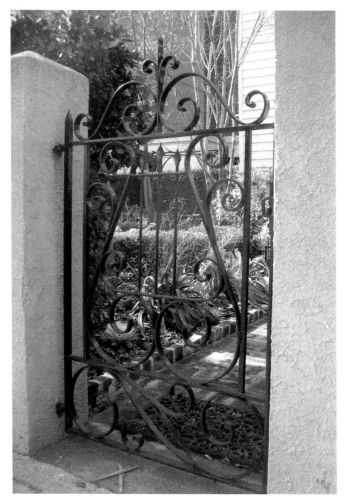

Philip Simmons's "Harp of David" gate.

property once belonged to the family of Anna Banks, one of the founders of McClennan/Banks Hospital.

6. 35 CALHOUN STREET

The Borough Houses

De hous' at tirty fy'b Killhoun Skreet bin buil' een eighteen fitty two by dem Irish people wha come yah. Een nynteen tirty nine, Mistuh Willis Johnson wha' bin bohn free on de Dray'n Hal' Plantayshum, buy de propitie. Een nyteen forty, two ob Willis sons, Frank 'n Henry, buil' tirty fy'b Kilhoun Skreet fuh uh khapentry test. Dees two hous' yah is de only two wha' stay yah een dis area, 'n stil' own by de same fambly. Dis area had plenny poor blacks libbin een ciddy-own project. Een nyteen eighty ny'n, Harrycain Ugo mek de dut bad, 'n de ciddy moob dem out tuh udduh place. Deh soon tay down de place.

The house at 35 Calhoun Street was built in 1852 by Irish immigrants. In 1939, Mr. Willis Johnson, who was born free at Drayton Hall Plantation, purchased the property. In 1940, two of Willis Johnson's sons, Frank and Henry Johnson, built 35½ Calhoun Street for a carpentry apprenticeship test. These two homes are the only two remaining structures in this area of the historic district of Charleston and remain in the Johnson family.

The surrounding area housed many poor blacks living in city-owned subsidized projects. The area was described

as a close-knit community and the people worked hard at keeping out undesirables. Outsiders perceived the area as dangerous because the people would go to any measure to maintain the safety of their community.

In 1989, Hurricane Hugo created a health risk in the landfill soil and prompted the city to move the people elsewhere. The buildings were soon demolished.

7. 28 INSPECTION STREET

Birth Site of Ernest E. Just

Erniss E. Jus' bin uh eddycatid man wah study 'e head 'bout dem crittuh 'n t'ings. 'E teach dem chillum at dah Howard University. He 'n odduh smaat frien' staat de Omega Psi Phi turnity. 'E paah bin Chals Junyah., who bin uh warf builduh, 'n 'e maah bin Mary wah teach obbuh de ribbuh 'n dey name de place Marywill, like she. 'E granpah, Chals Seenyah, staat de Nunity 'n Frien'ship Sy'te een eighteen fortie fo', whah help de black people wid de behrul rinshawnce. Erniss E. Jus' bin eddecated fus' fum Kimbal Newnion 'Cademy een Meridan, New Hampcha. 'E steady 'e head real good 'n deh ghee um scholarship fuh go tuh Daahtmout' College. 'E finish dah school wid high onnuh. 'E steady 'e head 'bout dem zoology 'n tings. Jus' bin de only black een 'e class ob two hunnud 'n eighty sebbin. Den too, 'e bin good een maaht, English, French, 'n Latin. Affuh 'e finish Daatmout' 'e gon' fuh wuk fuh Howard University. While 'e wuk deh, 'e staa't de 'Mega Psi

Phi 'Ternity. Laytuh 'e married uh gal name, Essel Highwarden, who bin uh teachuh at Howard. Deh had shree chillun: Maahgret, Highwarden 'n Maribel. Een nineteen sixteen, Jus' steady 'e head moh 'n git 'e doctuh degree. 'E dead fum cansuh een nineteen fortie one when 'e bin fifty eight. At Daatmout' deh 'stablish uh scholuhship chair een 'e nayme.

Ernest E. Just, marine biologist, researcher, faculty member at Howard University and founder of Omega Psi Phi fraternity, was the son of Charles Jr. and Mary Just. He was born in 1883. His father was a wharf builder and his mother a schoolteacher in the West Ashley subdivision that bears her name, Maryville. Mary Just was an educator and a religious leader who founded the first industrial school for blacks in South Carolina. Just's grandfather, Charles Sr., was a slave artisan and a member of a small mulatto slave population who benefited from city life. In 1844, he was one of eighteen people who founded the Unity and Friendship Society, a mutual insurance club for free Negroes.

Ernest Just received his secondary education from Kimball Union Academy in Meriden, New Hampshire. He was a top student at Kimball Union and received a scholarship to Dartmouth College. He was the only black in a class of 287 and completed his first year with top grades. He excelled in mathematics, English, French and Latin, and he made the highest grade in Greek ever

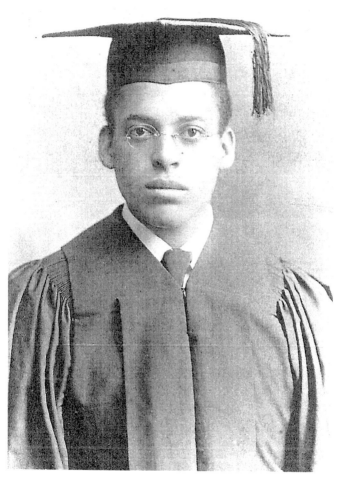

Ernest E. Just. *Courtesy of Dartmouth College.*

achieved by a Dartmouth freshman. Just graduated from Dartmouth *magna cum laude*, with special honors in zoology, honors in botany and sociology and the Grimes Prize for seniors. He was recruited by Howard University straight out of Dartmouth.

He later married Ethel Highwarden, an instructor in German at Howard. The couple had three children: Margaret, Highwarden and Maribel. In 1916, Just completed his doctorate.

In 1941, Just succumbed to pancreatic cancer and died at the age of fifty-eight. In 1982, Dartmouth College established a chair in his name.

8. 329 EAST BAY STREET

Philip Simmons Snake Gate

De Reb'lutionery Wor flag wid de snake wah say "Don' Tread On me" bin make by Chrisupher Gadstun. 'E son, Fullup Gadstun, bil' dis hous' 'roun' eighteen hunnud. Een nineteen sixty one, Sam'ul Stoney, who own de house, 'n Fullup Summons wu'k on de look fuh de gate. Aptuh Mr. Summons make 'n pit up de gate, 'e say de snake bin look so real dat de ummun ob de hous' bin 'frayd fuh come shru de gate.

The Revolutionary War flag with the snake and the statement "Don't Tread on Me" was designed by Christopher

Gadsden. His son Philip Gadsden built this house around 1800. In 1961, Samuel Stoney, the owner of the house, and Philip Simmons worked on the design of the gate. After forging and erecting the gate, Mr. Simmons said that the snake in the gate looked so real that the lady of the house was afraid to come through it.

9. 321 EAST BAY STREET

Grimké Sisters Home

Dem white Grimké ommun, 'n dey bredduh, wu'k haad fuh help free de slabe. De white people dem run um fum yuh 'n dey gon' up nort' 'n still wu'k een de moobment. Dah bredduh hab a school name fuh um 'n 'e marri' uh black gal.

Built in 1789, this was at one time the home of the Grimké family. The Grimké sisters were white abolitionists who were forced to leave Charleston because of their involvement in the abolitionist movement. They continued their work from up North around the Washington, D.C. area. An elementary school in Washington, D.C., is named for one of the Grimké brothers who was married to a black woman.

The Grimké sisters' home. *Courtesy of Avery Research Center.*

10. 290 EAST BAY STREET

Bennett's Rice Mill

Dis ol' Bennit Rice Mil' mek yah head tink 'bout all dem slayb dey bring yah fum Wes' Aff'iky fuh gro' de rice. De rice duh de one wah mek Chaa'stun rich. Cap'um Turbuh bring de rice seed yuh een de late sixteen hunnud fum Madagascar, obbuh deh by Wes' Afriky. Many Afikin cum yah 'caus' deh know how fuh plant rice. Rice cum yah too fum China, but 'e de long grain rice.

The façade of the old Bennett's Rice Mill is a reminder of the thousands of slaves brought from West Africa to cultivate the new rice plant. Their knowledge of rice cultivation made them an asset to the plantations and the rich economic growth of Charleston. Many Africans were advertised for their knowledge of rice cultivation. The rice seed is believed to have been brought from Madagascar, an island on the West Coast of Africa, to Charleston in the late 1600s by a white sea captain named Thurber.

Rice was also brought here from China. This long-grain rice from China was used mainly for planting. The rice from Madagascar was used for food onboard ships and what was left was used for planting.

11. 228 MEETING STREET

Site of Boot and Shoemaker Shop

'Roung eighteen sixty eight, Mistuh Caponie, a black man had 'e boots 'n shoe' makin' bidness yah.

Around 1868, A. Chaponie, a black man, operated a boot and shoemaking business in this building.

12. 93 ANSON STREET

The Heart Gate

De Haa't Gate, (de doub'l one dey een de back ob de chu'ch) 'zine by Fulup Summuns 'n deadekate een nineteen nihty eight wen de had de Splay'to fessval. St. Jon' duh weh Fullup Summuns go to chu'ch. 'E say 'e call em de haa't gate 'cus 'e say, "'e chu'ch duh stong tuh 'e haa't." St. Jon' bil yuh een 1850 fuh black Presaterian. Een 1861 'e 'blong tuh St. John Rohmun Cat'lic Chu'ch fuh de I'ish. 'E clos' een 1965 'cus deh stop cum'n. Een 1971 deh St. John Rahfom 'Piscable peepul buy em.

The Heart Gates (the double gates at the rear of the church) were designed by Philip Simmons and dedicated in 1998, with a Pearl Fryar topiary garden, during Spoleto Festival. Saint John's Reformed Episcopal Church is where Philip Simmons worships. He came up with the "heart" design because, he says, "his church is dearest to his heart." Saint John's was built in 1850 as the Anson Street Chapel for black Presbyterians. In 1861, it became Saint John's Roman Catholic Church and served a large number of Irish parishioners. It was closed in 1965 because of a drop in membership and was purchased in 1971 by Saint John's Reformed Episcopal congregation.

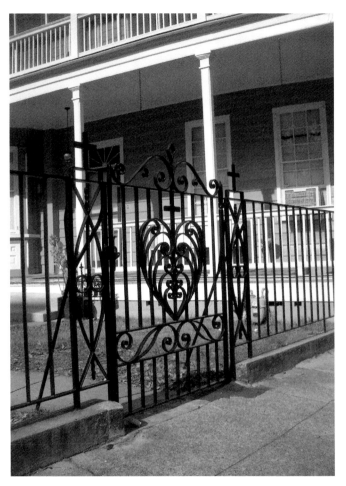

Philip Simmons's heart gate.

13. 121 Calhoun Street

Harleston Funeral Home

Mistuh Halstun bin uh jack-uh-all trade, 'e bin sea captin, rice plantuh, 'n had uh flunal bidnis yuh wid 'e bubbuh, Robbut. Dey call um Halstun Flunal. 'E boy Edwin bin uh all obbuh known pitchuh paintuh.

Edwin G. Harleston, a black man of many trades, was a sea captain, a rice planter and an undertaker. He opened his undertaking business in 1901, with his brother Robert, as Harleston Brothers Funeral Home. Edwin G. Harleston was a principal organizer and first chapter president of the local NAACP.

Many black businessmen, doctors, ministers, undertakers and other black independent business owners assumed leadership in the early civil rights activities.

The first site of the funeral home was on Meeting Street and it later moved to this location. Edwin's son, Edwin A. Harleston, was an internationally acclaimed portrait artist. Edwin A. Harleston's wife, Elise Forrest Harleston, was an acclaimed photographer.

14. 110 CALHOUN STREET

Emanuel AME Church

Manyul staat way yonduh een Fillydelpbia een sebbin teen eighty sebbin wen Richshud Allen leeb Syn Jawge Chu'ch. Dey keep on dah way 'til' dey done spread all obbuh, ebbin een Chaa'stun. Een eighteen eighteen, Moyse Brown, who bin wid Allen chu'ch, staa't tuh mek deh black people yuh fuh study deh head 'bout leebin' de white folk chu'ch. 'E pull tegedduh dem slabe, 'n free people fuh de Manyul Chu'ch wah fus' bin staa't een sebbinteen ninety one 'n staa't de new Manyul Chu'ch.

The roots of Emanuel go back to Philadelphia, where, in 1787, Richard Allen left Saint George Methodist Episcopal Church and started the African Methodist Episcopal Church. The movement spread, and in 1818, Morris Brown, an Allen supporter and a free black preacher, led the movement in Charleston to organize black Methodists into an independent organization. He reorganized the original congregation, which was started in 1791 and known as the Free African Society. It consisted of free blacks and slaves. Originally, Brown had created a circuit from the congregation of the Hampstead Church, the Anson Borough Church and the Philadelphia Alley Church in the French quarters of Charleston. In 1818, the three circuit churches were Emanuel's predecessors.

In 1834, the whites, remembering that Denmark Vesey had been a member of the original congregation, burned down the church and forbade the members to meet anymore. They met in secret until 1865, when they reorganized themselves and built a large wooden structure on the site at 110 Calhoun Street. The wooden building, which was designed by Denmark Vesey's son Robert Vesey, was destroyed in the earthquake of 1886. The current structure was completed in 1892 in its present Gothic design.

In 1882, the congregation was terribly overcrowded. To alleviate the overcrowded conditions, Emanuel bought the Zion Presbyterian building at 5 Glebe Street. Emanuel is said to be the only black church building in peninsular Charleston that was designed, built, governed and maintained by blacks. The others were donated, bought, governed or built by whites for their black congregations.

15. CALHOUN STREET

Killhoun Skreet bin neam fuh de gray't John C. Kilhoun. De staatchu deh pit deh tuh King 'n Kilhoun Skreet bin pit deh by dem Dauduh ob de Fed'rah'cy een 1887 close tuh de groun'. De black people dem mess um up so bad dat dem gals had tuh moob' em high weh 'e duh stan' deh now. Killhoun bin a smaa't man

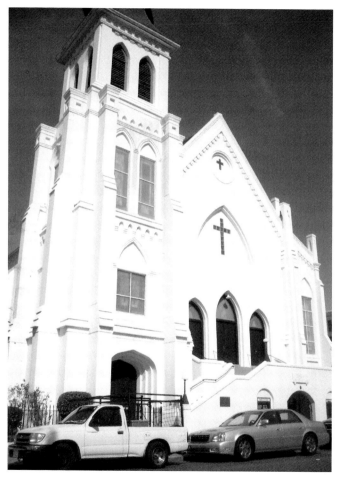

Emanuel AME Church.

too, 'n bin big een de gub'uhment, but 'e een bin no frien' tuh de black. 'E say, "Keep de nigguh man down; a hol' een de groun' keep de nigguh man down." De olduh blacks call dis skreet "Kilhoun' Skreet, 'n dey say, "We kin say 'Calhoun' we mean fuh say 'Kilhoun.'" Kilhoun duh de great, great gran' neppue tuh Leenuh Horn'. Kilhoun neppue, Dr. Andru Bonapaa't Kilhoun slabe had chillun fuh um 'n dey duh 'cendent tuh Leenuh Horn'.

Calhoun Street was named for John C. Calhoun. A statue of Calhoun, who was known as the "cast-iron man" of antebellum Southern politics, was erected in Marion Square by an organization called the Ladies Calhoun Monument Association, started by Amarintha Yates (later Yates-Snowden) and about eleven other ladies. In about a year's time they had raised around $16,000 to erect a monument for their beloved Calhoun. On June 28, 1858, Carolina Day, the cornerstone was laid, but the Civil War prevented them from going any further with the project. After the war, they reorganized and continued with the project. Sculptor A.E. Hennish of Philadelphia was selected to create the statue. The plans called for the statue to be made of bronze and stand on a pedestal surrounded by four females symbolizing History, Justice, the Constitution and Truth. The unveiling took place in April 1887, with Mrs. Calhoun present. The unveiling upset the

ladies—it definitely wasn't what they had requested. Calhoun's right index finger pointed in a deformed manner and instead of four ladies there was only one positioned in a subservient position. Blacks said that the lady was Mrs. Calhoun. The statue was on a low-base pedestal. Blacks so often desecrated the statue that the Monument Association had to go back and raise it up on a high-base pedestal. John C. Calhoun's motto was, "A hold in the ground keeps the nigger man down."

Calhoun is Lena Horne's great-granduncle. John C. Calhoun's nephew Dr. Andrew Bonaparte Calhoun's slaves had children for him, and they are the ancestors of Lena Calhoun Horne.

The new statue was commissioned and it was unveiled in June 1896. Present-day blacks refer to Calhoun Street as "Killhoun Street," which was brushed off as a speech impediment. An old lady exclaimed, "Oh please! We can say 'Calhoun,' we mean to say 'Killhoun'!" Blacks hated Calhoun for his stand on slavery.

In the June 26, 1991 edition of the *Evening Post* (*Post & Courier*), E. Randall Floyd, author of the book *Great Southern Mysteries*, wrote:

> *The road toward civil war between North and South was long and painful, with good men on both sides sincerely convinced of the rightness of their cause.*

One such man was John C. Calhoun, the ex–vice president and fiery senator from South Carolina whose impassioned stand on states' rights, slavery and nullification earned him a reputation as the South's leading intellectual architect of secession. Although he went to his grave a decade before the guns sounded at Fort Sumter in the spring of 1861, Calhoun apparently had a premonition of the coming conflict.

The chilling premonition had apparently come to the aging senator in a dream shortly before his death in 1850. Details of the dream were recounted over breakfast one morning to his longtime friend, fellow fire-eater and states' rights advocate Robert Toombs of Georgia. Toombs knew something was wrong the moment he sat down next to Calhoun. For one thing, he had never seen the old war hawk so worn and pale. It was obvious, the Georgian later noted, that something was bothering his friend, for not only did he look as if he had not slept in days, but he also kept tugging at his right hand for no apparent reason. Intrigued, the Georgia senator asked if anything was wrong.

"Pshaw!" Calhoun retorted, almost as if he were embarrassed by his strange affliction. "It is nothing but a dream I had last night which makes

me see now a large black spot, like an ink blotch, upon the back of my right hand." Calhoun, who then carefully concealed the troubled hand, called it "an optical illusion, I suppose."

Toombs responded: "What was your dream like? I am not very superstitious about dreams, but sometimes they have a great deal of truth in them."

Calhoun leaned back in his chair and sighed. He then began to unravel one of the strangest tales Toombs had ever heard. "At a late hour last night," Calhoun said, "as I was sitting in my room writing, I was astonished by the entrance of a visitor, who, without a word, took a seat opposite me. The manner in which the intruder entered, so perfectly self-possessed, as though my room and all within it belonged to him, excited in me as much as indignation."

Calhoun said that he had watched as the intruder drew closer. Then he made a startling discovery. "As I raised my head to look into his feature, I discovered that he was wrapped in a thin cloak which effectively concealed his face."

In a soft, strange tone the stranger spoke: "What are you writing, senator from South Carolina?"

Calhoun replied that he was "writing a plan for the dissolution of the American Union."

"*Senator from South Carolina,*" the presence whispered in a voice that crackled like the wind, "*will you allow me to look at your right hand?*"

At that moment the figure rose and his cloak fell away. Calhoun slumped backward, terrified at what he saw. "*I saw his face. The sight stuck me like a thunderclap. It was the face of a dead man whom extraordinary events had called back to life. The features were those of George Washington, and he was dressed in a general's uniform.*"

As if in a dream, Calhoun extended his right hand, as requested. He said a "strange thrill" passed through his body as the stranger grasped his hand and held it to the light. "*After holding my hand for a moment, he looked at me steadily and said in a quiet way, 'And with this right hand, senator from South Carolina, you would sign your name to a paper declaring the Union dissolved?'*"

At that moment, a mysterious black blotch appeared on the back of his hand. Alarmed, the senator asked: "What is that?"

"That," the stranger replied, "is the mark by which Benedict Arnold is known in the next world." The shadowy figure readjusted his hood and said no more. But from beneath the cloak he drew an object which he laid upon the table—the bony hand of a skeleton! "There," whispered the

stranger in a faraway voice, "are the bones of Isaac Haynes, who was hung at Charleston by the British. He gave his life in order to establish the Union."

Suddenly the stranger disappeared, along with the skeleton, and Calhoun awoke in his bed. He sat up, glanced around the room. It was empty. The strange intruder was gone. Then, recalling the dream, he slowly turned his eyes toward the back of his right hand. What he saw made him gasp. The black spot was still there—just as it had been during the dream!

16. CALHOUN STREET GREEN

Old Citadel

De middle paa't ob de ol' Citadel bin buil' yuh fuh uh State Assinul fuh de use ob de Nisapul Ghaad, aftuh Weesee caus' so much troub'l yuh een eighteen twenny two. Den too, dey bin gwoi use um fuh dey saf'ty when moh slabe troub'l staa't. Dey finish up de Assinul een eighteen tirty. De stat'u wuh deh de by de skreet is John C. Killhoun. A had-haddid man 'n mean tuh de blacks. Dis stat'u, fix yuh aftuh de Cibul War, bin put closuh tuh groun' but dey hice em up high 'caus' de blacks dem always chunk tings at um. Plenny uh cibul right meetin' gon' on yah

wah we call "de green." Latuh rafter de Cibul War, abolitionis' Willyum L. Garrison p'ruse b'fo' obbuh uh towsyn free men, ummun, 'n chillum 'n ex-slabe b'fo tawk'n' tuh dem een Big Zion Pressuhte'rn Chu'ch wuh bin at de connuh ob Killhoun 'n Meetin' Skreet. Dey maach yuh een nynteen sixty sebbin 'bout wohtin' right 'n odduh time when dey fus' 'bout deh freedom.

The central portion of the Old Citadel was erected as the state arsenal for use of the municipal guard following the attempted revolt of black slaves, known as the Denmark Vesey plot of 1822. It also was to serve as a haven for whites in the event of another insurrection by slaves. The arsenal was completed in 1830.

The open area in front of the Old Citadel, known as "the Green," became the gathering place for many civil rights rallies. After the Civil War, abolitionist William Lloyd Garrison paraded before thousands of freed men, women and ex-slaves before speaking to them in Big Zion Presbyterian Church once located at the corner of Calhoun and Meeting Streets. In March 1867, a rally was held here to celebrate the newly attained voting rights for black men. This area became the gathering arena for the 1960 civil rights demonstration in Charleston.

17. 342 MEETING STREET

Second Presbyterian Church

Staat yuh een Chaa'stun as de Sec'un Pressbuhterun Chu'ch ob de ciddy een de suburb ob Chaas'tun when dey buil' em yuh een eighteen leb'm. De say de chu'ch bin buil' outside de ciddy line. 'Fo' de Cibal War, de upstays is weh de black sit. Dey had obbuh two hunnud odd black membuh een disshuh chu'ch. Dey say Denmaak Weesee bin jyne dis chu'ch wid 'e mossa when dey fus come yah tuh Chaa'stun.

Organized in Charleston as the "Second Presbyterian Church of the City," when built between 1809 and 1811, the church was situated outside the city limits. Before the Civil War, the galleries were used by the church's more than two hundred black members. Denmark Vesey is believed to have been a member of that congregation when he first came to Charleston as a slave of Captain J. Vesey.

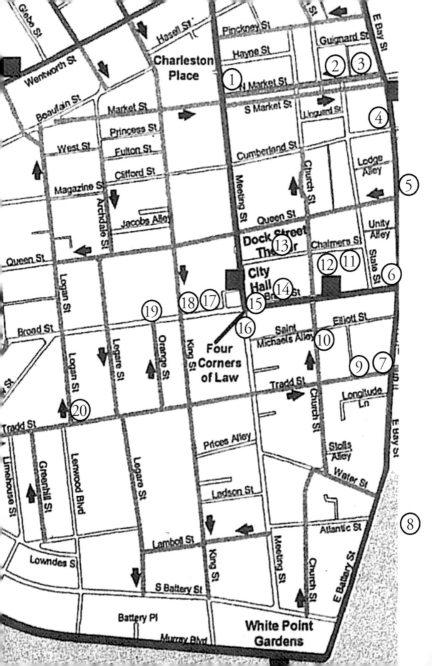

THE MARKET DISTRICT

1. 188 MEETING STREET

The City Market

*De lan' weh de Maahkit sit on bin ghee em yah by de Pink'ny fam'ly
'n de say deh kin sell any ting deh 'cep fuh slabe. 'N ef de mek de
head haad 'n sell slabe dehn de lan' haffah gib back tuh de fam'ly.
De fus buil'dn deh püt yah bin 'roun' sebbinteen eighty eight, 'n deh
sell meat, fish 'n wedghatubble. Latuh-ron dey buil' moh shed. Now
deh sell all kinuh tings yah, 'speshly dem baskit mekuh. Dem touris'
buckrah call de place de "skraw maahkit." Dem men bin de one who
binnuh mek de baskit fus. Deh mek um fuh wuk outside. Now de
ummun 'n de men mek de baskit, but moh ummun dahn man. Dem
baskit een dem mu'sum all obbuh worl' now.*

The property for the Old City Market was given to
Charleston by the Pinckney family with the stipulation

that it revert to the family if used for any other purpose, such as the selling of slaves. The first building was erected around 1788 and only meat, vegetables and fish were sold there. Many sheds were subsequently erected on the property but are difficult to date, as the market has been rebuilt several times due to fires and storms.

Vendors of all sorts now dominate the scene at the market, but the large number of basket makers selling their baskets there has caused it to be dubbed by tourists the "straw market." The baskets are "sewn," not "weaved," and are priced according to the number of hours that it took to make them. The men were the original makers of the baskets, which were mainly for outdoor use such as rice fanning. Joseph Foreman is one of many basket makers who sell their baskets at the market. His sister Mary Jackson has baskets in some of America's finest museums and galleries, including the Gibbes Art Gallery at 135 Meeting Street. Works by Mary and Joseph are referred to as an "investment in art."

2. 33 MARKET STREET

Drug and Chemical Store

Een eighteen sixty eight, Mistuh Simonds 'n Mistuh Denny, two black people, had dey drug stoh 'n tings yuh.

Old City Market.

Around 1868, Simonds and Denny, two black men, owned and operated their drug and chemical store on this site.

3. 24 NORTH MARKET

Leslie's Fish Market

De Leslie Fam'ly newstuh own dishuh place 'rung de last paat ob de nineteen cent'ry. Deh bin good 'n uppardy people 'n had plenny uh money. Laytuh-ron dey sell out tuh dem buckrah people.

This was the site of the Leslie's Fish Market, a prominent and lucrative black business in the late nineteenth century.

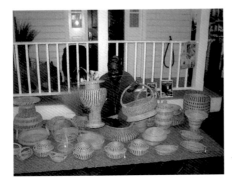

Joseph Forman, basket
maker.

It was owned and operated by Charles and Julia Leslie.
The Leslies had offices at 18 and 20 Market Street. Their
residence was at 79 Anson Street. They later sold the
business to the Carrolls, a white family, who operated here
until the 1970s.

4. 200 East Bay Street

The U.S. Custom House

*Dey staat bil'dn de new Custum Hous' een aateen fifty but de war
stop dem fum finish um. Dey finish um een aateen sebinty nine.
Wilum D. Crum, uh doctuh, wah finish school fum Ab'ry In'stoot,
University ob Sout' K'lin'uh, 'n Howard University, bin pick by
Presadent Roosebelt fuh be uh Poat Collectuh een nineteen 'o shree,*

but white people dem ain' make dah job to easy. Een nineteen odd eight Dr. Crum put Mr. Clan'ce O. Brown on dat job. Een nineteen twenty one 'e bin moob up to act'tn port 'prasuh, den een nineteen tirty nine, 'e mob up to weh 'e do now.

The erection of the Custom House, referred to as the "new" Custom House, began here in 1850, but construction was interrupted by the Civil War. The building was completed in its present form in 1879. William D. Crum, MD, a graduate of Avery Institute, the University of South Carolina and Howard University Medical School, was appointed port collector of Charleston by President Theodore Roosevelt in 1903, but racist response made it a short-lived experience.

In 1908, Dr. Crum appointed Mr. Clarence O. Brown collector of customs, the first and only Negro to be appointed to that position. Mr. Brown was born here in Charleston on November 13, 1885, and attended Simonton Public School. At Simonton, he had the highest scholastic average and won a scholarship to Avery Normal Institute, from which he graduated in 1903. After nearly a half century on the job, Clarence Brown received the very prestigious Treasury Department's Albert Gallatin Award for distinguished service. On September 1, 1912, Brown married Lydia O. Seabrook, who at that time owned a shoe store at 441 King Street. Together they had nine children, all of whom were college graduates and were

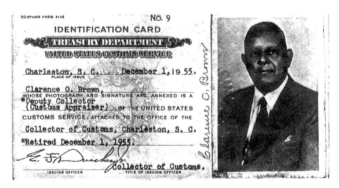

Clarence Brown. *Courtesy of Thelma Sumpter.*

employed in professional capacities. On March 2, 1960, at the age of seventy-five, Clarence O. Brown died at his residence at 245 Coming Street.

5. 9 VENDUE RANGE

Site of Pritchard's Cotton Factory

Eeen 1868, Mistuh Pritch'it had 'e cuttun fat'ry yuh een dis place.

Around 1868, J.C. Pritchard, a black man, had his cotton factory on this site.

6. 122 EAST BAY

The Old Exchange and Custom House

Fuh too long deh been sellin' de slabe from dishah place. Den de white missy dem, dey git bex 'cause dey ty'yd fuh see de buck-nekkid slabe out in de open. So de law dem change up 'n close up sellin' slabe fum yah. De law tell de people dat the auction block up de skreet wid de waggin 'n tings too much.

Old Exchange Building/U.S. Custom House. *Courtesy of Avery Research Center.*

One of the many functions that took place at the back side of this building, which was built around 1767–1771, was the selling of slaves. This was the tradition since the eighteenth century, but in 1856, after the "Southern belles" of the city complained about the unsightliness of the naked slaves in public areas, a city ordinance was passed prohibiting the sale of slaves in this area and in other public open areas.

7. 6 TRADD STREET

Embrey Mission
An Affiliate of the African Methodist Episcopal Church

Reblun Chals R. Findley staa't 'e AME Mishun Chu'ch yah roun' nineteen sebbinteen or eighteen. 'E rent uh little room yah 'n naym em Embrey Mishun fuh Bishup Embry. Den dey mob obbuh tuh Chalmuh Skreet 'roun' nineteen twenty two or shree een de pink house. Een 'roun' nineteen fawty dey mob obbuh to Hanobbuh Skreet 'n dey re-naym de chu'ch Beards Chu'ch name fuh one ob de great AME pastuh een Chaas'tun.

Reverend Charles R. Findley was born a slave on James Island. He was eighty-five when he died in 1939. He and his wife Rachel Findley were two of the founders of Saint

Reverend Charles and Rachael Findley. *Courtesy of Rachael Dowling.*

Luke AME Church. At that time, it was called Israel AME Church and was located on Wilson Street. In 1917, they rented a small room at 6 Tradd Street and started Embry Mission, named after Bishop J.C. Embry. In 1922, Reverend Findley moved the small congregation to the pink house on Chalmers Street. In 1940, after the death of Reverend Findley, the congregation moved to its present site on Hanover Street and renamed the church Beard Chapel, after Reverend J.E. Beard, a prominent minister in Charleston.

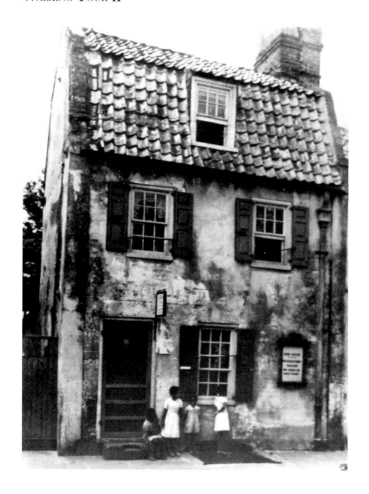

The Pink House. *Courtesy of Avery Research Center.*

8. BATTERY

Fort Wagner

Een de middle ob de oshun out deh is Fort Sumputuh. Dey staa't fuh bill um yah 'roung eighteen twenty nine but dey een nubbuh finish em 'caus de warh staa't. Ef you look tuh de right on Fort Sumutuh, all dah lan' you see dey is Morris Island. Das weh Fort Wagganuh bin at. Dem black soh'juh ob de Fitty Foht 'n Fitty Fif Massachusit ammy gone tuh de det in de wah. De moobie call Glory *sho' how de men bin kill.*

In the middle of the ocean, located between Sullivan's Island and Morris Island, is Fort Sumter. Construction of the fort began in 1829 and it was still not completed when the fort was occupied in December 26, 1860, by Union forces. The tract of land to the immediate right of Fort Sumter is Morris Island, where Fort Wagner was located. (The sand fort has been washed away by the ocean.) This was the site of the mortal battle fought by some of the Fifty-fourth Massachusetts regiment during the Civil War. The battle was memorialized in the movie *Glory*.

9. 9 TRADD STREET

Site of Anderson's Restaurant

Een eighteen sixty eight, Mistuh Anderson, a black man had 'e fine wittle eatin' place yah. 'E been one ob de finest een town.

In 1868, A. Anderson, a black man, ran a restaurant in this building. It was said to have been one of the finest in town.

10. 89–91 CHURCH STREET

Catfish Row

Dis shree room high hous' is weh Dubose Haywood steady 'e head for 'e book Porgy. 'E wife, Dora'ty mek uh play fum de book. She play em on Broadway. De George Gershwin man see de play 'n write 'e oppruh Porgy and Bess. De call dis place yuh "Catfish Row" but we black people bin call um "Cabbage Row." De um'un dem sell de cabbage on de winduh sill for sell 'n das why we call um "Cabbage row." Deh sho nuff bin uh Porgy. 'E tru' name duh Sammy Smalls. 'E git wrung een 'e khaat wha' pull by dah goat. Dah boy bin too mean. 'E senn' 'bout fo' man to de det enny always bin beatin' up on 'e gal frien' dem. Een nineteen twenty fou' dah po' felluh teck sick, moh den teck sick, somebody pit uh fix on Porgy 'n een long

b'fo 'e dead 'n bury een Burns Grabyaard at Jim I'lun Presuhteriun Chu'ch. Deh dig 'e grayb Nort' tuh Sout' so 'e spirit kin hont de unknown fixuh.

This three-story double tenement structure served as the inspirational setting for George Gershwin's opera *Porgy and Bess*. Gershwin's opera was based upon the book *Porgy*, written by DuBose Heyward. This site was originally known as Cabbage Row because the black inhabitants would place their cabbages and other produce out on the window ledge for sale.

The character "Porgy," whose real name was Sammy Smalls, is depicted as a fun-loving, easy-going cripple in both the book and the opera. In real life, Smalls is said to have lived a cruel and murderous life, in which beatings of his common-law wives and girlfriends were part of his daily activities. He was a crippled beggar who got around in his goat-drawn cart. Young men and boys with goat carts were once a common sight on the streets of Charleston. His lifestyle led to his being "fix" (hexed). In 1924, Smalls died and was buried in Burns Cemetery at James Island Presbyterian Church. Smalls's grave was said to have been dug north to south. If one died mysteriously, as Smalls did, the grave would be dug in this manner. It was believed that spirits could not rest turned crossways and would always haunt the unknown assailant—the assailant would die in a matter of weeks.

Catfish Row. *Courtesy of Avery Research Center.*

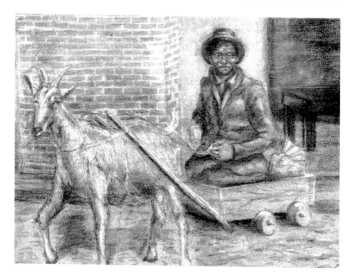

Porgy (Sammy Smalls or Goat Sammy). *Courtesy of Sammy Smalls Family.*

11. 3 CHALMERS STREET

Site of Anderson Boardinghouse

De Andusun, had deh boadin' hous' yuh 'roung eighteen sixty eight.

The Andersons, a prominent black family, opened a boardinghouse here around 1868.

12. 6 CHALMERS STREET

The Old Slave Mart Building

Een eighteen odd fifty six de law stop sellin' slabe on de Nort' side ob de exchenge place, 'n enny open place. So Mistuh Runyon open up 'e slabe sellin' bidness at dis place yah. Dey call um de Runyon Slabe Maakit. De Chalmuh Street side bin de back 'den. De front paa't bin on de Queen Skreet side. When dey had uh sellin' ebby ting bin don' fum de coaht yaad, 'n den send een dis bild'n fuh aukshun.

In 1856, a city ordinance was passed prohibiting the selling of slaves on the north side of the Custom House (the Old Exchange building). This resulted in the establishment of "sales room," "yards" or "marts" along Chalmers, Queen and State Streets and Vendue Range, and a four-story slave jail *barracoon* (Portuguese word for "jail"), office space, a morgue and a kitchen, all fronting on Queen Street with a yard extending to Chalmers Street. The auction block/table was located in this building and was hidden from public view.

The building was first opened as a museum in 1937 by Miriam Wilson. At that time it was the only museum in America that exhibited African American artifacts of the slavery era. The museum was closed upon the death of Miss Wilson in 1959. It was reopened in 1961 by sisters Judith Wragg Chase and Louise Alston Wragg Graves. In

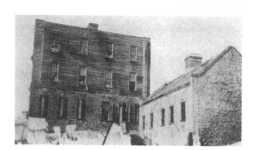

Ryan's slave jail and kitchen.
Courtesy of Avery Research Center.

1950, the *Negro Digest* reported that Miss Wilson had stated that slavery had been good for African Americans and they had been freed too soon. The museum is presently owned by the city and is open to the public.

13. 36 AND 38 CHALMERS STREET

Jane Wright Homes

Een eighteen turty fiyb, Miz Jayne Wright white man keepuh buil' dis hous' yah fuh she 'n 'e fam'ly.

In 1835, these two houses were built by a white jeweler for his black mistress Jane Wright and her family.

14. 56–58 BROAD STREET

The Freedman's Bank

Fum eighteen sixy nine tuh eighteen sebbenty fo', dis place yah been de Freedmun Bank. Dey bin s'pose fuh help de new free slabe git money 'n tings fuh staat 'e bidness. Dey also say dat we fuh git de forty aches 'n uh mule wah Shermun say we fuh git. Dem khaahpit bagguh fum up Nort' run de bank down 'n teef ebbyting.

This double building, which was built in two stages (number 58 in 1789 and number 56 in 1800), served from 1869 to 1874 as one of the several branches of the Freedman's Bank, a national bank for blacks.

General Sherman initiated Field Order No. 15, which gave forty acres, a mule and other necessary items to the newly freed slaves from the properties that were abandoned by slave owners during the Civil War. Congress never approved Field Order No. 15, and many slave owners returned to their properties and reclaimed their land.

These banks were created to aid blacks in their reconstruction efforts following the Civil War, but mismanagement and manipulation by white New York financiers caused the banks to fail.

Freedman Bureau/Bank. *Courtesy of Avery Research Center.*

15. 71 BROAD STREET

Site of Jones's Hotel

Mistuh Burrah had 'e shree room high hous' yah 'roun sebbinteen sebbinty two. Mistuh Jones, uh free black man, buy dis hous' 'n open up uh fine hotel. Latuh ron 'e sell um to dem St. Michael people 'n buy de one next doh to dat one. He 'n 'e wife, Mis' Abuhgail run de place 'til Mistuh Jones gone on een eighteen turty shree. Dey son, Edwud bin de fus' black ma fuh finis' college een 'Merike. E finis' fum Amhuss' College een eighteen twentie odd six. Den 'e gon' tuh Afrike fuh staat de Fouray Bay College een Serruh Layons. 'E udduh son, Jehu Juneuh steady 'e head wid de Luterin prechuh yah. 'E latuh

gon' on tuh Filliedelpeiuh weh 'e staat de fus black luterin chu'ch een
'Merike, Sint Paul Ebangelical Luterin Chu'ch.

William Borrows built his three-and-a-half-story wooden mansion here around 1772–74. In 1815, Jehu Jones, a free black man, purchased this property and opened a lavish hotel, which was later sold to Saint Michael's Church. Saint Michael's later razed the building for extension of its churchyard. At a public auction six years later, Jones bid $13,000 for the adjacent lot and house. Jones and his wife Abigail turned the house into an inn that catered to travelers on extended visits. Jones also purchased slaves to work in his various enterprises. Jones continued to operate his hotel until his death in 1833. His son Edward is said to have been the first black college graduate in America. He graduated from Amherst College in 1826 and was one of the founders of Fourah Bay College in Sierra Leone. Jehu Jr. studied ministry under the Lutheran ministers in Charleston and later went on to Philadelphia, where he founded the first black Lutheran church in America, Saint Paul Evangelical Lutheran Church. The building is presently a part of the University of Pennsylvania.

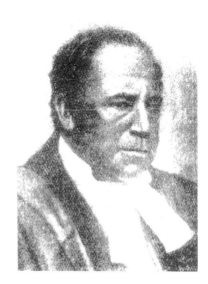

Edward Samuel Jones.
Courtesy of Amherst University.

16. 80 MEETING STREET

Saint Michael's Protestant Episcopal Church

Dis chu'ch is de ol'dis chu'ch buil'dn een de ciddy ob Chaas'tun, but not de ol'dis people. Sint Fillup got de ol'dis people. Deh buil' Sint My'cal yah 'round sebbinteen sebbinty one, aftuh deh moob Sint Fillup fum yah een sebbinteen ten obbuh to Chu'ch Street. Durin' de Rebalushun Wah, dem British sohjuh teef de bell fum out de steeple 'n khaa'm obbuh to England but deh senn' um back. Dem bell don' cross de 'Lantic oshun obbuh six time fuh one reason or uh nudduh.

St. Paul Evangelical Lutheran Church in Philadelphia. *Courtesy of Shelton Goodwin.*

De las' time 'e git back yah, 'e bell ringuh, Washintun McLean Gadsden, a black man, bin so glad. 'E kin mek good music fuh de ciddy.

Saint Michael's is the oldest church building standing in the city of Charleston, but not the oldest congregation. Saint Philip's, on Church Street, is the oldest congregation. Saint Michael's was built around 1771 after Saint Philip's moved from its small, black cypress building in 1710 and built a new structure on Church Street. During the Revolutionary War, the bells of Saint Michael's were taken to London by the British. They were later sent back. The bells crossed the Atlantic about six times for various reasons. When they were reinstalled after the Civil War, the bell ringer Washington McLean Gadsden, a black man, once again started pelting out the beautiful melodies that filled the ears of Charlestonians with joy. The first songs he played that day were "Home Again" and "Auld Lang Syne." He served as bell ringer for twenty-seven years until he retired in 1894. Gadsden played for many city-sponsored events and private organizations. His main love, of course, was sacred music. Listeners would pause every Sunday morning and evening before service to hear the music.

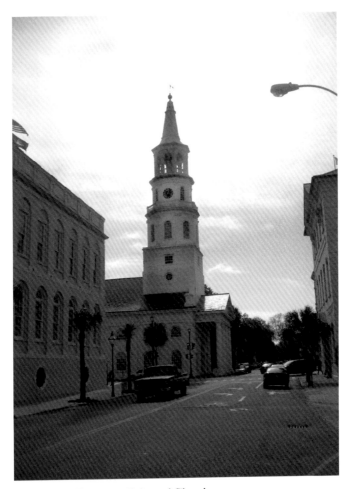

St. Michael's Protestant Episcopal Church.

17. 89 BROAD STREET

De Large's Magistrate Office

'Roung eighteen sixty eight, dis bildin' yah bin weh Madraskate De Laadge, uh black man, had 'e office.

Around 1868, Robert C. De Large, a black magistrate, occupied this building for his office. De Large was a delegate to the People's Convention of 1868.

18. 91 BROAD STREET

Law Office of Whipper, Elliott and Allen

Mistuh Willyum Wippuh, Mistuh Robbut Brown Ellot, 'n Mistuh Macun Allen, staa't yah de fus black law bidness een Amerike. Mistuh Ellot bin a Wes' Indun, 'n eddeycated at Eton College een Englin' Mo'ron, 'e wu'k fuh de Missionary Recodduh, de oldess black newspepuh een Amerike, 'n print out by de Afrike Metuhdis' Piscopal Chu'ch Bishup, Richa'd Cayn een Chaa'stun.

William Whipper, Robert Brown Elliott and Macon Allen established the first black law firm in America and occupied this building for their offices around 1868.

William James Whipper was the son of a well-known and wealthy Philadelphia family. He was a prominent black lawyer in Beaufort, South Carolina, and a black Reconstruction legislator. His wife was Frances Ann Rollins, daughter of a free, black, antebellum family in Charleston. The late Reverend Benjamin Whipper, the former pastor of Saint Matthew's Baptist Church and Charity Baptist Church, was the grand-nephew of William J. Whipper.

Robert Brown Elliott was born in 1842 in Liverpool, England, where he was educated at Eton College and learned typesetting. He served in the British navy and arrived in Boston about 1867. That same year he moved to Charleston, where he worked with soon-to-be Congressman Richard H. Cain. Elliott served as an associate editor of the *Missionary Recorder*, a newspaper of the African Methodist Episcopal Church and the first black newspaper in America. Elliott was a leading figure at the 1868 state constitutional convention. In 1868, Elliott was elected to the South Carolina House of Representatives. While serving in the House, he studied law and was admitted to the South Carolina bar in September. In May 1881 his job with the Treasury Department transferred him to New Orleans. Elliott died in New Orleans on August 9, 1884.

Macon B. Allen, born a free black, was the first black licensed lawyer in the United States. His birth place and

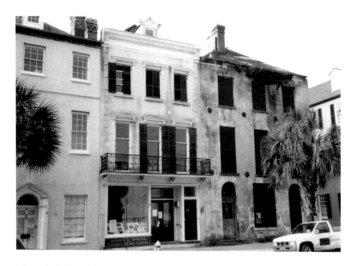

First black law firm in America, Whipper, Elliot and Brown. *Courtesy of Avery Research Center.*

date are not certain. He passed the law examination before the Western District Court of Maine and one in the state of Massachusetts. He was a member of the South Carolina State Senate. In 1873, the South Carolina Senate elected him judge of the Inferior City Court of Charleston. Allen was one of the first black justices in the United States. Charleston became his permanent home. He was a member of Saint Mark's Episcopal Church and is buried in Charleston.

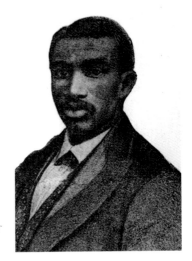

Robert Elliot Brown. *Courtesy of Avery Research Center.*

19. 116 BROAD STREET

John Rutledge House

Wen Mayuh Rhett bin libbin' yah, 'e butluh, Willyum Deas, uh cullud man, enwent "she crab soup." Dah bin een nynteen twenty. Mayuh Rhett had big pattie 'n een kno' wha' fuh ser'b 'e comp'ny. Willyum Deas tell fuh ley'un dress up 'e new soup call "she crab." Well, Mayuh Rhett trus' um fuh ser'b. So 'e add 'e orange crab egg. De comp'ny like um so dat dey call de soup, "Willyum Deas' soup." Dey latuh call um "she-crab soup." Deas got so good dat latuh-ron 'e gone fuh wuk fuh a cullud man

name Everett Presson. Presson had ressurunt 'n motel on Cannon Skreet een 'e tek 'e ressapee wide em. Dah ressapee deh on ebby menu in Chaas'tun.

In 1902, Mayor Robert Goodwyn Rhett purchased this house. According to tradition, it was here that his black butler and cook William Deas created "she-crab soup." Mayor Rhett was known for his lavish parties. At a special occasion, he needed something different to serve to his guests. William Deas suggested that he dress up the old pale soup that was usually served with some orange crab eggs to improve the flavor. The soup was definitely a hit and later became known as "William Deas' Soup," and finally "she-crab soup." After Mayor Rhett died, Deas accepted a job at Everett Presson's (a black man) restaurant on King Street and took his recipe with him. A few years later, the restaurant was moved to Presson's new restaurant and motel on Cannon and Courtney Streets. She-crab soup is a tasty appetizer that now graces the menu of many fine restaurants.

20. 6 LOGAN STREET

Home of Reverend Jacob Legare

'Roung eighteen sixty eight, Reblun Jaycub LeeGree lib yah. 'E bin de fus' preachuh on Moise Skreet Baptist Chu'ch.

Around 1868, this was the residence of Reverend Jacob Legare, the first pastor of Morris Street Baptist Church.

THE COLLEGE OF
CHARLESTON AREA

1. 20 FRANKLIN STREET

Home Site of Jenkins Orphanage

De ol' Myreen Hosspit'l bin finish een eighteen thuty fo'. But moh long deh stop tendin' to dem people, 'n dah hospit'l close down. Den een eighteen nihty one when Reblun Jenkins ax' fuh dah place to rais' dem no-home chillun weh 'e pick fum de skreet, deh gyeem. Reblun Jenkins fus' place bin at six hunnud 'n sixty King Street, but 'e bin to little fuh all dem chillum. Dem orfin chullum steady de head fo' kno' how fuh play dem hawns 'n tings, 'n like Gay'bryl all obbuh dah U'rup land 'n deh pay plenny money fuh hear-rum. Moh long, een nineteen odd tirty nine deh mob obbuh tuh de Nort' ob Chass'tun two yea' aftuh Reblun Jenkins pass on.

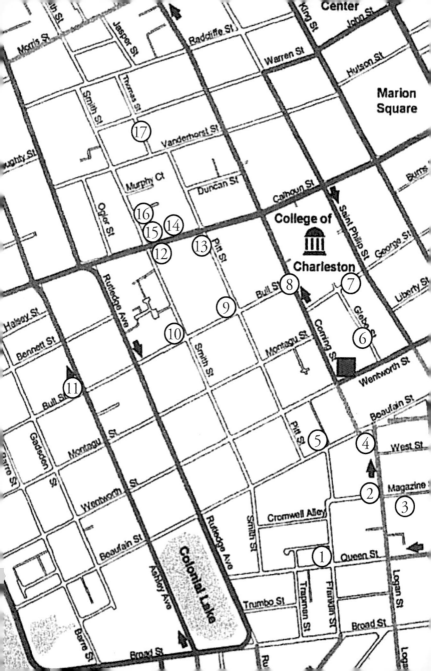

The old Marine Hospital, completed in 1834, served as the second home for the waifs of Jenkins Orphanage, founded by Reverend Daniel Jenkins in 1891. The first site, located at 660 King Street, was described as a mere shed. Through the efforts of local white dignitaries and the members of Tabernacle Fourth Baptist, where Jenkins was the pastor, the use of the old Marine Hospital was granted in 1893. In its first two years it provided for 360 children, and by 1896, 536.

Reverend Jenkins taught the children many different occupations. Some of the skills taught were baking, farming, butchering, printing, housekeeping, academics and music. Many of the former residents became printers, teachers, ministers and musicians. But the orphanage became famous for its band. The famous Jenkins Orphanage Band toured Europe and the United States to raise funds for the orphanage. It gained national and international recognition. Once, while in New York, the band members met the ragtime composer James P. Johnson and he taught them a selection from his musical *Runnin' Wild*. In addition, he taught them a dance movement that went along with the music. They were probably very familiar with the dance steps, since they were believed to have originated in Charleston and were made popular by Herman Brown. When he was a teenager Herman Brown hopped a freight train to New York and, like the other children in New York, he would do street dances similar to those he had done as a

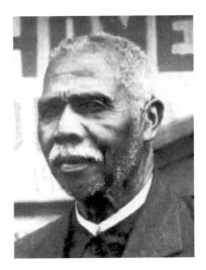

Reverend Daniel Jenkins.
Courtesy of Sarah Findley Dowling.

child in Charleston. Herman was often called upon to come up and do that "crazy dance" he did down in Charleston.

Upon returning home, the Jenkins Band played Johnson's music on the streets of Charleston and also performed the dance steps he had taught them. The white ladies would come and imitate the boys doing the dance steps. That dance is now known as the Charleston, Herman Brown's dance.

James P. Johnson's *Runnin' Wild* came to the stage in 1924.

In 1937, Reverend Jenkins died, and two years later the orphanage was moved to 3923 Azalea Drive in North Charleston.

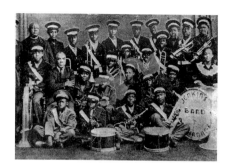

Jenkins Orphanage Band. *Courtesy of Sarah Findley Dowling.*

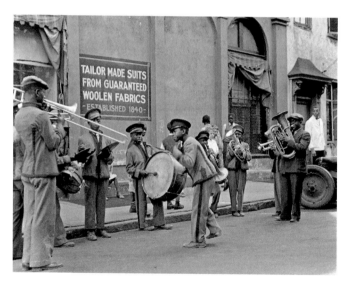

Jenkins Orphanage Band. *Courtesy of Avery Research Center.*

Herman Brown, Mr. Charleston. *Courtesy of Rossie Colter.*

2. 15 MAGAZINE STREET

The Site of the Work House and the Old Jail

De fus Wu'k House bin buil' yah 'roung sebbinteen sixty nine. Uh new one bin buil' yah 'roung eighteen tirty eight. De mossa dem bring deh haad head slabe yah fuh lickin'. Dey had fuh pay twennie fy'b cent fuh a lickin' or wu'k on de treadmill. Dey redduh de lickin' 'dan de treadmill. 'E bin een dis same place weh Denmaak Weesey top people bin lock up 'n chain down tuh de flo' b'fo de law fin' em

gilty for insurrectshun and den hang um. Plennie slabe 'n free man gon' tuh Hebbun right fum dis yah place. De place got so raggy date en eighteen fifty deh had fuh mek uh new one wid runnin watuh. De ertquake shek um down een eighteen ettie six.

De ol' jail buil' yah een eighteen od two bin fuh white prisonnus. Aahchitek Robbot Mills, who draw up de Washin'tn Monument een Washin'tn, D.C., 'n plenny buildin een Chaa'stun, draw up uh new fo' story wing wid one man cell een eighteen twenty two. De wing bin tek down een eighteen fity fy'b 'n een eighteen fity six de present octic'en towuh bin finish. De towuh 'n de fo' story secshun bin tek down aftuh 'e bin damage' een de er'tquake ob eighteen aa'ty six. Dem fo' white man who push up Denmaak Weesey fuh 'surrect bin put een jail yah. De long lis' 'clood, teef, murdruh, pirate 'n Cibil Waah knewnion Pridnur. De er'tquake 'skroy de wukhous' too much 'n de coud'n fix em back up. De black 'n de white all bin put een one jail now. De ol' jail clos' up een nyteen tirty eight when deh buil' uh new one furduh up on Eas' Bay Skreet nea' de Cuppuh Ribbuh.

The first Work House was built here around 1769. A new one was built around 1838. It was one of two municipal sites for punishing slaves. Unruly slaves were often brought here by their masters for punishment. The punishment usually consisted of a twenty-five-cent flogging or grinding corn on the treadmill, depending on the severity of the crime. It is said that prisoners preferred flogging to the treadmill. Until around 1839–40, the Work House

The Work House/
Whipping House.
*Courtesy of Avery
Research Center.*

became the exclusive place for selling slaves. It was this site where the four trusted lieutenants of Denmark Vesey's insurrection—Peter Poyas, Nedd Bennett, Roller Bennett and Gullah Man Jack—were bound in chains before their trials and subsequent hangings. Peter Poyas, the head lieutenant, seeing that the men were about to crack under the fear and stress of the proceedings, admonished them to "tell nothing" and to "die like men."

Whites became very fearful for their lives and designed measures for their protection. The *cheval-de-frise* at the Miles Brewton house at 27 King Street was placed there after the 1822 planned insurrection. Brewton was a leading slave merchant and operated several slave ships.

The Work House also served as a place for executions. In 1769 it was here, on the grounds of the whipping house, where two slaves—Dolly and her husband Liverpool— were burned alive for poisoning a white infant. A new

Chevaux-de-frise.

Work House, built in 1850 with plumbing and steam heat, was destroyed in the earthquake of 1886.

The Old Jail, built in 1802, was for white prisoners. Architect Robert Mills, who designed the Washington Monument in Washington, D.C., and many buildings in Charleston, designed a new four-story wing with one-man cells in 1822. The wing was taken down in 1855, and in 1856 the octagonal tower was completed. The tower and the four-story section were taken down after they were badly damaged in the earthquake of 1886.

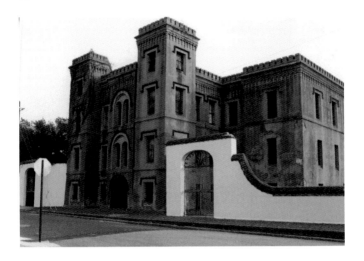

The Old Jail. *Courtesy of Avery Research Center.*

The four white men who encouraged Denmark Vesey's insurrection were imprisoned here. The long list of prisoners included thieves, murderers, famous pirates and Union prisoners. The Paddy Wagon behind the Old Jail is referred to as "Black Maria," but blacks refer to it as "Black Lucy." Hearing the iron wheels of Black Lucy coming down the streets was a signal for blacks, especially men, to hide. If the police couldn't find who they were looking for, it is said that they would take the first black man they found. The term "Paddy Wagon" is said to have derived from the time when the British would take the

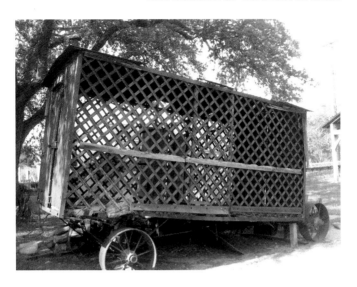

Paddy Wagon/Black Maria.

Irish prisoners in paddy wagons. They would often refer to their captives as "Paddy Boys," a derogatory term.

The earthquake of 1886 damaged the Work House beyond repair and both blacks and whites were housed in the Old Jail. The jail was closed in 1938, when a new one was built farther up on East Bay Street near the Cooper River.

3. 5 MAGAZINE STREET

Home of James Skivring Smith

De hous' B'fo' dis one is weh Doctuh Jaymes Skivr'n Smit' lib. 'E bin de fus' medical doctuh wah finish college een Amerike. 'E bohn een Chaa'stun on Febbuhrehry twentie six to free black maah 'n paah, Carlos 'n Catrin Smit'. 'E udduh brudduh 'n sistuh is: Mary, Maggret, Ann, Doretuh, Catrin 'n Carlos. Jaymes bin de fo't chyle. Een eighteen tirtie shree Carlos moob 'e fam'ly to Liberia. De got deh een Monrobia on Jannuhrery sixteen eighteen tirty shree. Aftuh uh yea' tyme Carlos 'n Catrin bin dead ob de Afikin sleep sickness. Deh call um malaria. Dem chillin duh now orphan. Jaymes staa't fuh wuk wid de Ameriky Colonizashun Cyety. Jaymes latuh come back tuh Ameriky 'n study 'e head at Wermont Medical College. 'E latuh transfer obbuh to Berkshire Medical Insuhtute 'n een eighteen forty eight finish up wid degree een medicine. 'E latuh gone back to Liberia 'n bin uh doctor fuh de Ameriky Colonizashun Cyety. Smit' bin president ob de Republic ob Liberia fum eighteen sebinty one 'til Jannuhrery eighteen sebinty two. 'E son bin politishun. When las' check een 1892, Smit' bin lib een Buchanan, Liberia. We een kno' wen 'e dead.

The previous house that stood at this site was the home of Dr. James Skivring Smith, the first black medical doctor to have graduated from college. Smith was born in Charleston, South Carolina, on February 26, 1825, to

free blacks Carlos and Catharine Smith. His other sisters and brothers were Mary, Margaret, Ann, Dorothea, Catharine and Carlos. James was the fourth child. In 1833, Carlos Smith moved his family to Liberia. They arrived in Monrovia on January 16, 1833, and the children were orphaned within a year of their arrival. Carlos and Catharine died of African Fever (malaria). James Smith became interested in medicine when he started working under Dr. James W. Lugenbeel, a white physician who worked for the American Colonization Society. Smith later returned to America and studied medicine at Vermont Medical College. He later transferred to Berkshire Medical Institute in Pittsfield, Massachusetts, and in 1848, received his medical degree. He was the first black American to receive a medical degree. Dr. Smith later returned to Liberia, where he served as a medical doctor for the American Colonization Society. From November 1871 until January 1872, Smith served as president of the Republic of Liberia. His son James Skivring Smith Jr. became a politician and lived in Liberia until around 1950. As of 1892, Dr. Smith was still living in Buchanan, Liberia. His date of death is unknown.

4. 122 LOGAN STREET

Fielding Home for Funeral

Mistuh Julius Feelin' 'n 'e fam'ly dem staa't deh fluenuhrul place yuh een nineteen fo'teen. Deh do good fuh de people down yah. Mistuh Julius son, Herbut, bin de sec'un black man been wote in dah state hous' since de Cibal War bin obbuh 'n de Nort' people come yuh 'n reskruckshun we. 'E got uh nudduh son, Bernaad who bin uh Chaa'stun County Probate Judge. Deh fluenuhrul house bin buil' 'roung sebbinteen nin'ty one.

Founded in 1912, Julius P.L. Fielding founded Fielding Home. Born, reared and educated in Charleston, he became a business-minded young man working with his father in his horse-drawn livery business. When his father died, his mother remarried and his skills in business worked well for him as he helped his stepfather in his barbershop. He attended the Agricultural and Normal Institute in Orangeburg (now South Carolina State University) and then went on to Renouard Embalming School in New York. In 1912, he opened his funeral home at the corner of King and Queen Streets. In 1916, he married Sadie E. Gaillard Fielding and they later moved the business to 61 Logan Street, with a simple sign that read, "Julius P.L. Fielding, Undertaker and Embalmer." The ever-expanding business was once again moved,

in 1928, to its present location in a building that dates around 1791. Julius and Sadie Fielding died in 1938. In 1939, Emily F. Fielding incorporated the business, and along with her three younger brothers—Herbert, Timothy and Bernard—changed the name to Fielding Home for Funerals. Emily died in 1975, and Timothy became president until his death in 1982. Presently, the business is still being run by Herbert U. Fielding, Bernard R. Fielding, Julius P.L. Fielding II, Mark J. Fielding and David M. Fielding. It is the oldest continuously black-owned family business in Charleston. The Fielding family has offered affordable services to the Lowcountry for many years. Herbert Fielding was the second black since Reconstruction to be elected to the South Carolina State Senate. His brother Bernard won a highly contested bid for the position of Charleston probate court judge, never before held by an African American.

5. 71 BEAUFAIN STREET

Site of Calvary Episcopal Church

Dem 'Piskubble dycese people buil' uh chu'ch fuh deh black membuh. 'Fo' dey kin finish de white men dem try fuh tay um down. But de law tell dem fuh talk um obbuh wid de Piskubble people fus'. De law win 'n dey finish de chu'ch. De black membuh mob out een nineteen

First Calvary Church.
Courtesy of Avery Research Center.

fo'ty 'n buil' uh nudduh chu'ch on Line Skreet 'tween nineteen fo'ty one 'n fo'ty two. Housen Thority buy up de place, tay de chu'ch down 'n buil' dem progic.

The church was built for black communicants by the Episcopal diocese between 1847 and 1849. It was the oldest Episcopal mission established prior to the Civil War that was exclusively for the enslaved population. A white mob, protesting a separate church for blacks, tried to halt its completion. The mob was stopped by James L. Petigru, a Charleston attorney, who persuaded its members to voice their grievances through the proper channels. The white mob also resented the use of enslaved artisans and workers who were members of the church and were hired out for lower wages. With the matter resolved, the small classic revival structure was subsequently completed as planned. Between 1941 and 1942, the congregation left the building and erected a new church at 106 Line Street.

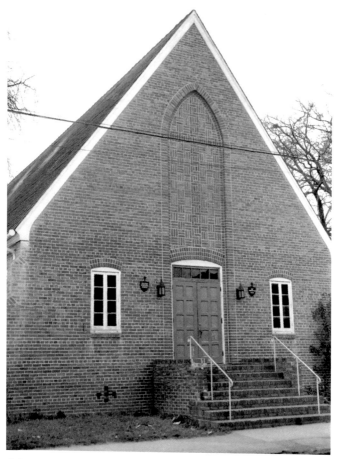

Calvary Episcopal Church. *Courtesy of Avery Research Center.*

6. 5 GLEBE STREET

Mount Zion African Methodist Episcopal Church

Manyul Chu'ch on Kil'loon Skreet had too much membuh, so dey buy buildin' fum dem Zion Presaterun people een eighteen eighty two. 'E bin de fuss brick chu'ch house fuh black people een de ciddy. Dem mulatto bin de fus one wah lef' Manyul 'n jine Mump Zion. The founduh 'n fus' pastuh ob Zion bin Reblun Norman B. Sterret, uh brayb 'n holy man ob Gawd, who leed uh skarry moobment fuh buy dis buildin'. On Sunday, Orgus twentie sebbin eighteen nihty shree, uh bad cyclone wayb obbuh de ciddy 'n 'mos' tay down de buildin' 'n bruk up de new pipe organ. By de end ob eighteen nihty fo' dem people had don' buil' back de buildin'. Den een nineteen tirty sebbin uh fire mes' up de front paa't ob de chu'ch 'n 'skroy de organ 'ghen 'n dem bun up de steeple. Aftuh dat dey fix em up 'ghen. Dem een eighteen eighty six uh er'tquake come 'n try fuh shake em down but 'e hol' up good. Dees people bin high eddecated.

To relieve the overcrowded conditions at Emanuel AME Church on Calhoun Street, this building was placed up for sale and was purchased by Emanuel in 1882. It was the first brick church owned by blacks in Charleston. Most of the original congregation that left Emanuel is said to have been mulatto. The founder and first pastor of Mount Zion was Reverend Norman B. Sterret, a brave and holy man of God, who led a harrying movement to secure the church's purchase

against disgruntled whites. On Sunday, August 27, 1893, a terrible and unprecedented cyclone swept through the city and almost entirely demolished the building and the newly installed pipe organ. By the end of 1894, a determined and hardworking congregation had rebuilt their sanctuary. A fire in 1937 damaged the front part of the church, taking away the steeple (which was never replaced) and the pipe organ in the balcony. A strong-willed congregation again made rapid repairs and continued gathering in their house of worship. The earthquake of 1886 did little damage and required only a few earthquake bolts. During the Civil War, the Fifty-fourth and Fifty-fifth black Massachusetts

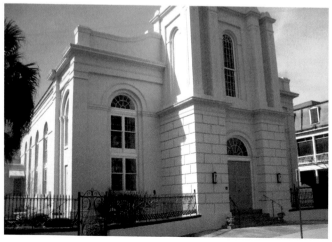

Mt. Zion AME Church.

regiments worshiped in the building. Unlike many of the newly formed black congregations that catered to light-skinned blacks, Mount Zion is said to have had the largest number of educated professionals than any other black congregation in Charleston.

7. 66 GEORGE STREET

The College of Charleston

Disha school fus staa't yah een sebbinteen ninety fo'. 'E duh de oldiss nissaple college een de Nu Nineted State. De state duh tek kay obbuh-rum now. Durin' de years to come, de college continuh fuh buy up property 'roung um. Mis' Lizzybit Jon'son, uh free cul'ud ummun, own de house at numbuh two Green Skreet since eighteen forty fo'. De Bell fam'ly own um nex'. De College buy de house fum de Bell family. Wen dey rennuhwate de hous' een nineteen sebbinty dey fine de reccud book ob dem Brown Fellaship people. Dem book deh een de Abrey school lybury now. Miz Sepunnuh Claak git de on'arrehy Doctuh Degree. Dey call dah leck'cha hall she name. De collage own de Abry buil'dn now too. Doctuh U'gean Hunt, who git 'e job deh een 1972, bin de fus' black wah dey ghee de tinuh too.

Established in 1790 and opened in 1794, the College of Charleston became the oldest municipal-owned college in

the United States. It is now state supported. From 1844, the house at 2 Green Street (the street is now closed) was the home of Mrs. Elizabeth Johnson, "a free person of color," and her descendants. It was later the residence of the Bell family, proponents of the civil rights movement. Record books of the Brown Fellowship Society were found inside the house when it was being restored by the College of Charleston in the 1970s. These record books are housed in the Avery Research Center for African American Studies. The college conferred upon Mrs. Septima Clark an Honorary Doctorate Degree and named a lecture hall in her honor. Its first black, tenured faculty member was Dr. Eugene C. Hunt, a professor of English who was hired in 1972.

8. 2 BULL STREET

Site of Denmark Vesey Capture

Een eighteen twennie two, shree week aftuh 'e try fuh free de slabe, de law ketch Weesee yah at de home ob one ob 'e eight wife. All dem wife bin slabe.

In 1822, about three weeks after the discovery of his insurrection plot, Vesey was captured here at the residence of one of his eight wives. All his wives were slaves.

9. 33 PITT STREET

Residence of Alonzo Ransier

'Roun' eighteen sixty nine, dis house yah is weh Lonza Ransie lib. 'E bin one uh dem Lutennint Gub'nuh fum eighteen sebbinty 'n wuk deh 'til eighteen sebinty two wen 'e bin wote fuh repasent de Sec'nd Congress Diskrick een de Newninted State House ob Repuhzent. Some dem white people unskruction de black people 'n pit Ransier back down tuh Chaa'stun. 'E bin bohn free on Jin'ary thurd, eighteen tirty fo'.

Around 1869, this was the residence of Alonzo Ransier. Ransier was elected lieutenant governor in 1870 and served until 1872, when he was elected to represent the Second Congressional District in the U.S. House of Representatives. He was a Republican in the Reconstruction government after the Civil War, but was disenfranchised when whites began to dismantle Reconstruction. Ransier was born free in Charleston on January 3, 1834, and received a primary education.

10. 56 BULL STREET

Former Home of Denmark Vesey

Dis yah dah de home ob Denmaak Weesee. 'E buil' em yuh 'bout eighteen twenty one. 'E duh de one wah stirrup de slabe

head fuh freedom een eighteen twentie two. 'E come fum de Wes' Indies a slabe 'n 'e buy 'e freedom wen 'e win some money een de Chaa'stun lottrie. Dem saylus unrabble deh mout' wide m 'bout how dey tek obbuh Santo Duhmin'go. Weesee had uh berrie good plan fuh free de slabe. 'E had dun git obbuh eight towsin odd slabe een 'e plan. Deh bin goin' kill de buckrah, git all de money fum de bank, set fire all obbuh de place, 'n boad dem ship back tuh Santo Duhmin'go, or Afriky. De plan got bungle up wen Peetuh Praylo', uh hous' slabe ob Carnul John Praylo', tell on um. De law ketch Weesee 'n deh hing de res'. Deh law pit up all kyn uh rule fuh keep de black people een deh place.

This small, frame, freedman-style house, built around 1821, is believed to have been the home of Denmark

Denmark Vesey's home.

Vesey, the leader of an aborted slave insurrection in 1822. Vesey, a native of the West Indies, was brought to Charleston as a slave and bought his freedom from money he won in a lottery. Having corresponded with other black Revolutionary sailors of Santo Domingo, Vesey laid out one of the finest military strategies in history. To help execute his plot, he had enlisted over eight thousand slaves in Charleston in a radius of over fifty miles. His plans included robbing the banks, killing the whites, burning the city and seizing ships for transporting insurrectionists to Santo Domingo. The plans fell through when a slave involved in the plot shared the secret with a trusted and loyal slave, Peter, who belonged to Colonel John C. Prioleau. After an in-depth investigation, Vesey and thirty-four blacks were tried in a closed and defenseless court. They were publicly hanged on Blake's lands, near Charleston.

11. 125 BULL STREET

Avery Normal Institute

Buil' yah een eighteen sixty eight, dis bin Chaa'stun fus' seconnary school fuh blacks. Revlun Ca'doohzuh git de money fum Mistuh Chals Abbrey. Wen 'e ghee um, dey name de school like um. De Free'mun Offis buil' de school on de lan' de Missionary Sosee'ashun

ob New York buy fuh dem. De school bin pribit 'til nineteen forty sebbin, den ennybody wid uh little bit ob money could go deh. Een nineteen fity fo' de school close up 'n jyne wid Burke school. Abbrey now duh de Resuch Sentuh fuh Afikin Rimereken History 'n culyuh. 'E tek kaah ob by de Callege on Chaa'stun. 'E duh muszeum house fuh resusch fuh we black fuh steady weh deh come fum.

Built between 1867 and '68, this was Charleston's first secondary school for blacks. It was organized in 1865 by the Reverend Francis L. Cardoza, who secured a $10,000 grant from the Charles Avery Foundation. The foundation later named the school after the philanthropic Methodist minister. The school was private until 1947, when it became a public institute that later merged with Burke in 1954. It is now the Avery Research Center for African American History and Culture. It maintains a museum, a research room of genealogical records and other documents related to the history of Lowcountry blacks. Many leading members of Charleston's black community received their educations at Avery. Graduates include T.M. Stewart, a Liberian Supreme Court justice; Dr. R.S. Wilkinson, president of South Carolina State College (now South Carolina State University); and Richard E. Fields, the first black in modern times to be named as judge of the Municipal Court of Charleston and the second black circuit judge.

12. 94 SMITH STREET

Home Built by Morris Brown

Mistuh Moyse Brown buil' dis house yah 'bout 1814. 'E bin uh free black pree'chuh who bin de main one wah tell de black fuh lef' de white Medduhdis Chu'ch 'n come jy'n de nu Afikin Medduhdis Piscupul Chu'ch. 'E lib on de cornnuh ob wentwurt 'n Ansun Skreet. Een eighteen twenty two 'e had tuh leeb Chaa'stun cus' de law tink 'e bin mix up wid Denmaak Weesee. 'E gon' up the Phillydelphy 'n mek preachuh up deh. Dey mane Moyse Brown Chu'ch on Moise Street for um 'n de Moyse Brown colledge een Ah'lanta een 'e name.

As an investment, around 1814–1822, Reverend Morris Brown built this plain but nicely framed single house. He was a free black minister and was the prime force in Charleston in organizing blacks into the newly founded (1816) African Methodist Episcopal church. At that time, he lived at the corner of Wentworth and Anson Streets. In 1822, he was compelled to leave South Carolina because the authorities suspected him and the local AME church of being involved in Vesey's insurrection. He went to Philadelphia, where he continued in the ministry and subsequently became an AME bishop. Morris Brown AME Church on Morris Street and the Morris Brown College in Atlanta are named in his honor.

Rental property built by Morris Brown. *Courtesy of Avery Research Center.*

13. 52–54 PITT STREET

Site of the Brown Fellowship Society and Burial Ground

Dem free black ma'lattuh staa't dey Brown Felluhship C'cyety een sebbinteen ninety fo', 'n buy dis piece uh lan' fuh dey grayb yaad. De grayb yaad deh at fi'ty fo' Pitt Skreet weh de College lyberry people paak de khaah. Een nineteen fity sebbin de Bisshup Englan' school wah bin yah buy de lan' 'n mob sum ob de big stone to de big colored grayb yaad up town 'n payb obbuh de grayb 'n smalluh stone. Fum the middle ob the propaty, sep'rated by uh wood'n fense, gwoin t'ward Comin' Skreet is de grayb yaad ob de C'cyety ob Free Daak Men, 'n latuh'ron deh call deh sef "De Humain C'cyety." Dis Cyety bin staa't by Thomas Smalls, uh free black man. Smalls, een eighteen fo'ty shree try fuh jy'n de Brown C'cyety but couldn't 'caus' 'e bin daak skin. Brown Fellowship bin light skin black people.

In 1790, James Mitchell and four other mulattos organized the Brown Fellowship Society, the "Brown" referring to their almost-white complexions. It is the oldest of the Negro-friendly societies in the state. The society prohibited the discussion of religious or political matters. Its members were cautious of "ruffling the feathers" of their white relatives. The Brown Fellowship Society was opened to free blacks of very light color, and maybe those who were a few shades darker but had naturally straight

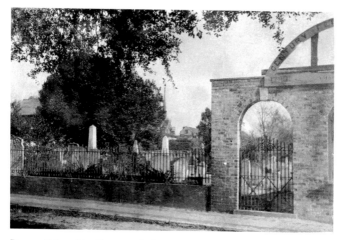

Brown Fellowship Graveyard. *Courtesy of Avery Research Center.*

or "blowing in the wind" hair. Unlike other benevolent societies started by free Negroes, the Brown Fellowship did not help the slave community. Some members were slave owners. Many of the free black organizations that were later started purchased slaves and manumitted them.

The first order of business for the Brown Fellowship was to purchase property for a meetinghouse and a burial ground. The chosen site for the meetinghouse was on Liberty Street. The site chosen for the burial ground was located between Boundary (now Calhoun), Pitt, Coming and Bull Streets, now the parking lot and green area behind the College of Charleston library (the former site

of Bishop England High School). It was in this area that, in 1794, the cemetery was consecrated by the rector of Saint Phillip's, Thomas Frost.

The society provided for more than the burial of its members. It cared for members' widows, provided a primary school for their children and supported members' business endeavors. Another important function of the society was the lobbying of their white "friends" (a word used to denote their white relatives) in power to maintain their privileged status. The society never would have gotten involved in anything like Denmark Vesey's insurrection. As a matter of fact, it was William Penceel, a member of the society, who persuaded Peter Prioleau (later changed his name to Desverney) to inform his master of the impending slave revolt planned by Vesey.

The Brown Fellowship Society's admission policy (which was tied to the white bloodline of former masters) denied membership to many blacks in Charleston. In 1843, Thomas Smalls, a free black man, applied for membership in the society and was turned down because of the darkness of his skin and possibly because his hair was not straight enough. Smalls, a member of the Circular Congregational Church, organized his own society calling it "the Society for Free Blacks of Dark Complexion." It was later renamed the Humane Brotherly Society. In a spiteful move, this group purchased property adjacent to the Brown Fellowship graveyard that extended from

the middle of the parking lot (separated by a fence) to Coming Street and opened its graveyard there, calling it "MacPhelah." To be a member of this society and to be buried in the graveyard, one had to be of pure African descent. Thomas Smalls also opened another cemetery for the black members of the Circular Congregational Church and named it "Ephrath." Most of the Ephrath cemetery is still intact, with the exception of larger headstones that have been pushed over and lined up as a walkway into the garden now on the property. Most of the deceased buried in Ephrath were black members of the Circular Congregational Church on Meeting Street. The Plymouth Congregational Church (now on Spring Street) gradually separated in a friendly manner from the Circular Church around 1867. They worshipped at 41 Pitt Street and used the old Ephrath graveyard until around 1950, when it was abandoned.

After the Civil War, the Brown Fellowship Society tried to change its image of exclusiveness by opening its doors to others, including women. In 1892 it changed its name to Century Fellowship Society. In 1943, taxes were levied against property owners to pay for sidewalks. In 1945, two elderly descendants of the Century Fellowship, unable to pay the high tax on a piece of property that was no longer in use, sold the graveyard property to the Catholic diocese. There were many blacks living at the site of the old Bishop England High School who were told that they

would be relocated to make way for the new school. A former resident of that area said that the depression of having to leave their homes was so great for some that they died of grief before they could relocate. In 1957, Bishop England expanded and needed some parking space. The old graveyard was a prime spot. Blacks who lived in the area knew that in the haste for expansion, the bodies were never removed. Only three, large obelisk stones and a few other larger stones were moved and were placed in one of the black graveyards on upper Meeting Street. For years, the desecration of the gravesite was written off as a local "fib." Only two graves were removed from the Bishop England site by a descendant of a society member.

For many years, officials of the Catholic Church claimed that all the stones and remains had been removed, but blacks who lived around the Bishop England area knew differently. The local "fib" was validated when four gravesites were discovered along with the headstones on January 15, 2001, when the property was being cleared to make way for a new college library. The smaller flat stones and the remains of the Brown Fellowship Society members were paved over. Under the asphalt are the remains of many prominent black Charlestonians. Pieces of tombstones were stacked up behind the outbuilding of the College of Charleston's Blacklock House until around 1998, when they disappeared. Ironically, one stone listed the deceased as a Catholic. Inside the former outbuilding,

a larger stone was pieced together. This property abuts the former Bishop England parking lot. The names of the society members and the minutes of their meetings can be found at Avery Institute of the College of Charleston.

In 1990, the descendants of the Century Society (Brown Fellowship) reorganized themselves, went searching for the stones and found three obelisk pieces. They bought a strip of property adjacent to the other black graveyards on upper Meeting Street. These stones were beautifully erected in memory of their descendants, whose remains lay quietly under the asphalt behind the College of Charleston library, the site of the former Bishop England High School.

On February 7, 2008, on the Rivers Green (backyard of the College of Charleston library) a twin tower African American cemetery memorial monument was dedicated in memory of the blacks who are buried here. This is the first monument in Charleston to give recognition to the black past.

14. 222 CALHOUN STREET

Old Bethel Methodist Church

Ol' Bessel, wuh bin yah sence sebbinteen ninety eight, duh de tur'd oldis chu'ch house een de ciddy. Een eighteen fity two dey why't

Bethel Methodist slaves and free blacks graveyard.

membuh dem moob de chu'ch tuh de Wes' side ob de groun' 'n ley de black membuh use um fuh dey pra' hous' aftuh dey buil' deh new chu'ch. Een eighteen eighty deh why't membuh had de ol' chu'ch moob obbuh de skreet tuh way 'e deh now 'n gheeum tuh deh black membuh.

Old Bethel, built in 1797–98, is the third oldest church building in the city. In 1852, the building was moved to the west end of the church grounds and used there for class meetings of Bethel's black members after the present brick church of Bethel Methodist was built. In 1880, the old building was given to the black members and was rolled across Calhoun Street to its present location.

This stone has only one word inscribed on it: the name "Dorinda."

Inscribed on this stone is the symbol of a hand with the index finger pointing up. It is believed to be a Muslim symbol meaning "one God."

This stone of Polly Scott reads: "In her the character of a good Christian is exemplified as a domestic, ever submissive to the will of whom God had placed over her."

The Methodists were said to be the kindest and most lenient to their slaves, and when possible, the first to free them. The new Bethel, built in 1852 on Pitt Street, maintained a cemetery on the site for its slaves and free blacks. The cemetery is now a parking lot, and some of the stones can be viewed along the wall in the unpaved section of the parking lot.

According to a former black sexton/custodian, Bethel, like many other churches in Charleston, is definitely haunted.

15. 96 SMITH STREET

Home Built By Richard Holloway

So 'e kin hab suppin' fuh fall back on, Mistuh Richard Holloway, a free black mastuh khapentuh, buil' dis house 'n 'bout twenty udduh small hous' 'tween eighteen twenty two 'n eighteen terdie (also at two twenty one Killhoun Skreet). All 'e hous' kinuh look de same. Mistuh Holloway bin uh membuh ob de Brown Fellowship Cyety.

As an investment, Richard Holloway, a free black master carpenter, built this and about twenty other small, frame single houses between 1822 and 1830. (See also 221 Calhoun Street; an early deed refers to a schoolhouse in the rear of 221 Calhoun Street.) Distinctive features of these houses are the Palladian windows in the front gables and the piazzas under the main roofs. Holloway was a member of the Brown Fellowship Society.

16. 109 SMITH STREET

Former Home of Julia Ann Rutledge Kiett

Dis lid'tl hous' fix yuh aftuh eighteen eighty, usetuh b'long tuh Julia Ann Rutledge. She bin hitch to Mistuh Wade H. Kiett, uh black school teetchuh.

Rental property built by Richard Holloway. *Courtesy of Avery Research Center.*

This small, frame single house was built after 1880 for Julia Ann Rutledge Kiett, wife of Wade H. Kiett, a black teacher.

17. 14 Thomas Street

Saint Mark's Protestant Episcopal Church

Dis Greek 'vival chu'ch buil'dn bin buil' yah een eighteen sebbinteen fy'b to 'roun' eighteen sebbinty eight. 'E ser'b uh black 'Piscupul congrigashun wah repuhzent uh moob to independence fum de "white mudduh chu'ch." Des people yah bin organize een eighteen sixty fy'b, 'n deh meet at de old Orph'n Hous' Chapel on Wanduhhoss' Skreet b'fo' dey buy de lan' yah een eighteen sebbinty fy'b. Lyke plenny ob de black congregation, de git tired wid how de white people dem treat um, so de leeb. De stay 'dough with de 'Piscupul di'cese. Some udduh people gon' wid the reform 'Piscupul Chu'ch lyke de one dey had een New York. Een eighteen eighty fy'b, St. Maa'k had wantin fuh hab black priest. De di'cese got bex wid um 'n would'n layem sit een de conwenshun. Een bin 'til 'roun' nineteen sixty fy'b when dey 'cep um.

This Greek revival church building was erected in 1875–78. The building served a black Episcopal congregation, who represented the move toward independence from the white "mother Episcopal churches" that were prevalent in almost all denominations. The congregation was organized in 1865, meeting first at the Orphan House Chapel on Vanderhorst Street before purchasing this site in 1875. Suffering many indignities, many of the free blacks left Saint Philip's Episcopal to establish their own

independent congregation. Saint Mark's remained true to the Episcopal diocese. There were some blacks of Calvary Episcopal Church who broke away and formed Holy Trinity Reformed Episcopal Church, affiliating with a newly established order in New York. Around 1885, Saint Mark's began to employ black priests. This angered the diocese, and members of Saint Mark's were denied seating at diocesan conventions. This issue was not resolved until 1965.

Richard E. Dereef was said to be one of Saint Mark's most prominent members and he made a substantial donation to the construction of the church. Reverend Saltus was the first black priest of Saint Mark's.

Driving Tour

The sites in this tour are a little bit farther off the beaten path, so hop in your car or hire a petty cab and visit some more important landmarks of Gullah Charleston.

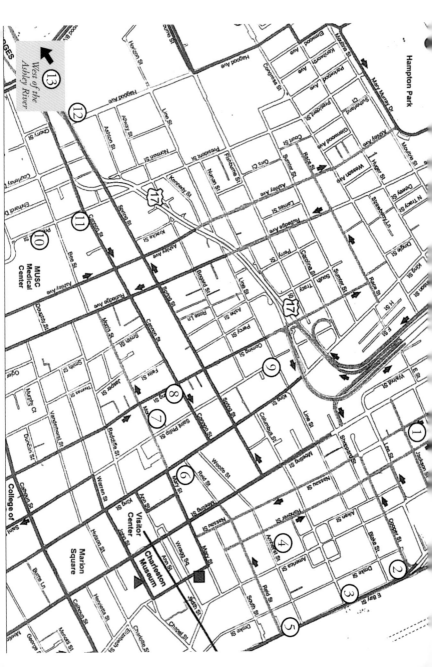

1. Sanders-Clyde Elementary School

Sanduss-Clyde Ellament'ry school bin name fuh early twentie cen'try eddycatuh, Ellen Sanduss, 'n Flaw'nce Birdie Clyde. 'E duh one ob de fus' school in de ciddy naym in honuh ob uh black pusson. Een two towsen', de buil'dn bin tek down fuh dem fuh buil' uh new one. Also een two tow'sn sebbin, de chillum dem bin rec'nize by the State fuh 'e continu' high school wuk.

Sanders-Clyde Elementary School was named for early twentieth-century educators Ellen Sanders and Florence Birdie Clyde. It is one of the first schools on the peninsula named in honor of a black person. In 2007, the building was torn down to make room for a new one. Also in 2007, the students were recognized by the state for their continuously high academic achievements.

2. 30½ Blake Street

Philip Simmons's Home

Mistuh Fullup Simmons, bawn June nyn't nineteen twel'b, duh one ob 'Merica oldis libbin blacksmith fuh obbuh sebbinty fo' yea' 'E lib yuh on Blake Skreet. 'E mek yuh obbuh two hunnud od gate 'n udduh i'yon tings een de las' fity yea' ob 'e life. 'E mos' famemus wuk duh de gate at de Smit' Sawn'ion, de Sous Kalinuh Sate Moozesum, de gate

*at Chaa'stun Wisituhs Cennuh, 'n de Snake gate at shree twenny one
Eas' Bay Skreet. De wuk wah sho' 'e gen'yus is de fus one 'e mek call
de Jack Krawcheck gate b'hind shree fifteen King Skreet.*

For over seventy-four years, Philip Simmons (born June
9, 1912), America's oldest living blacksmith, operated his
shop behind his modest home on Blake Street. He was
drawn to the shop of Peter Simmons at the age of nine
but was told that he was too young and that the horses
would kick him over the moon. He was told to come back
when he was thirteen. On Thursday, June 9, 1925, he
turned thirteen, and on Friday, June 10, he went to Peter
Simmons's shop and became an apprentice until Peter
gave him the shop. He has been there ever since, trained
and working as a blacksmith.

Over the years and after the emergence of more
automobiles on the streets of Charleston, the need for a
blacksmith became scarce. Mr. Simmons found himself
trying his hands at other things like making trailers that
could be hitched behind cars. The assembly lines of Sears
and Roebuck and others could produce a trailer faster and
cheaper than he could.

In 1948, fate intervened just in time when Jack
Krawcheck, a downtown clothier, asked Mr. Simmons
to make a gate for the backyard of his store at 313 King
Street. Mr. Simmons was surprised by the request and told
Mr. Krawcheck that he has never made a gate before. Jack

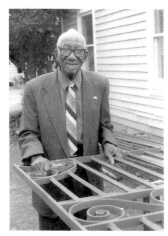

Above: Philip Simmons's home.

Left: Philip Simmons.

Krawcheck told him to bend the iron the same way he bends the horseshoes. Located behind 313 King Street is the first gate of the folk art genius Philip Simmons.

He designed and made over five hundred documented gates, balconies, railings and ornamental ironworks in the last fifty years before retiring. Some of his most famous works include the gate that was made at the Folk Life Festival in Washington, D.C., now at the American History Museum at the Smithsonian; the gate at the South Carolina State Museum in Columbia, South Carolina; the "Gateway to the City" at the Charleston Visitors Center; and the snake gate at 329 East Bay Street, to name just a few.

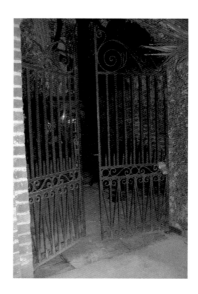

Philip Simmons's first gate.

The doctor retired Mr. Simmons from doing the physical work around 1990, but he still designs and oversees the forging now being done by his first cousin Joseph Pringle, who runs the shop, and his nephew Carlton Simmons.

The shop, located in the back of Mr. Simmons's home, is the same shop that was owned by Guy Simmons. Guy Simmons later passed the shop to his son Peter Simmons. Peter Simmons retired at the age of ninety-eight and passed the shop to Philip Simmons (no relationship) as a wedding gift. The shop was moved about seven different times at different places, but always on the east side of town. In

1925, it was at 4 Calhoun Street, where Peter Simmons had the shop before turning it over to Philip Simmons. Philip Simmons later moved the shop to 72 Alexander Street for sixteen years and temporarily to Calhoun and Concord Streets. He made another move to Lauren Street for sixteen years and then moved again to Calhoun and Marsh Streets. The next moves were to 11 Alexander Street, 44 Alexander Street and 29 Blake Street. In 1960, Mr. Simmons bought the property across the street and moved the shop to its present site. Some of the tools in the shop date back to the early 1800s. Of special interest is a pliers-type tool that was used by Guy Simmons to take the musket balls out of the moles. Most of the tools were handmade. It sometimes took longer to make a tool than to complete the task it was intended to perform. It was a matter of pride to make your own tools.

Mr. Simmons often gives credit to the old German gate makers who told him that if you have your patterns, then you have the whole gate. The patterns lining the back wall of the old blacksmith shop were made over the years by Mr. Simmons, Joseph Pringle and Carlton Simmons. They still make patterns when necessary for those special, intricate designs that are required of them. Presently, Joseph Pringle and Carlton Simmons are designing and turning out the beautiful ironworks made in the same way that Mr. Simmons made the many ironworks around Charleston—by hand.

Simmons's
blacksmith shop.

3. AMERICAN TOBACCO COMPANY

Een nyteen forty fy'b, de black wukkuh skrike 'caus' ob unfair laybuh praptis' at de Cig'ah Fat'ry. 'E bin at dis ty'm dat de song, "We Shal' Obbuhcome" bin use as uh protes' song. De black leaduh dem bin run way fun deh. De fac'try latuh close 'n hab udduh bidnes' moob deh. Deh had yah de Johnson 'n Whay'l Cookin' School. Een 2005, dey mood to Chall'lt, Nort' K'lina.

In 1945, the black workers went on strike because of unfair labor practice at the Cigar Factory. It was at this time that the song "We Shall Overcome" was used as a protest song. The black leaders of the strike were fired. The factory was closed and the building later housed different businesses. The building was also the home of a branch of the very prestigious Johnson and Wales Culinary School. In 2005, Johnson Wales moved to Charlotte, North Carolina.

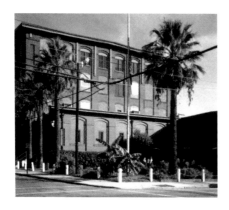

American Tobacco
Company/Cigar
Factory. *Courtesy of
Avery Research Center.*

4. 42 AMHERST STREET

James Brown Home

*Dis little two story wood'en hous' wid de pan tile roof bin buil'
yuh aftuh eighteen eighteen by Jaymes Brown, a free man ob culluh.
Brown bin a mulattuh butchuh wuh buy 'e whyfe, Nancy, 'n keep
de male chillun, John, 'n Jeams, fuh slabe. 'E would free free dem
dough' if 'e could.*

This small, two-story wooden house with a pantile roof
was built after 1818 by James Brown, a free person of
color. Brown was a mulatto butcher who bought his wife
Nancy and held her and their sons, John and James, as
nominal slaves; though, no doubt, he would have freed
them if he could.

5. 635 EAST BAY STREET

Hamitic Hotel

Dis house bin staa't yah een 'roun' eighteen tirty six by Henry Faybuh. Faybuh dead een eighteen tirty nine 'n 'e brudduh, Josup' finish up de house. Den Joshwah John Wah'd, uh lutennint Gub'nuh ob Souse K'lina, buy de hous'. Aftuh de Worl' War I, some cullud men buy em 'n open up uh hotel 'n call'um de Hamitic Hotel. 'E bin one ob de few lodg'n fuh cullud people. 'E latuh bin house' ob ill-repute 'n kaytuh by dem sailor and wartuh front wukkuh. Deh laytuh close down dah place.

Henry Faber built this Palladian villa around 1836. Faber died in 1839, and the house was completed by his brother Joseph. Later it was the home of Joshua John Ward, a lieutenant governor of South Carolina. After World War I, it became the Hamitic Hotel, one of the few lodging facilities in the 1930s available to black travelers and the community. In the 1940s and early '50s it became a "house of ill-repute" that catered to the seamen and others around the waterfront. The property was later abandoned. In 1965, it was purchased by the Historic Charleston Foundation to save it from being demolished. The building presently serves as office space.

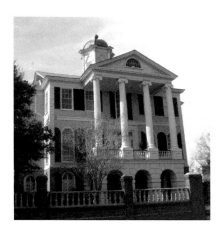

Hamitic Hotel.

6. 22 MARY STREET

The Shaw Center

De basement duh all wuh lef' ob a two flow up buildin' mek ob wood on uh brick basement pit yuh 'bout eighteen sebbinty foh.' Dey fix em fuh eddycate de blacks. Den dey name um fuh Robbut Gould Shaw, who bin de head ob de Fity fo't Massatusit Regiment fuh free blacks ob de New'unn, doin' de Cibal War. Plenny de sodjuh bin kill at Bat'try Wagnuh on Moyse' I'lun een eighteen sixty shree. Dey mek de mobbin pitcha 'bout dem sodjuh 'n call um Glory. *De buil' up de place back 'n staa't uh boys club, 'n day kay cennuh.*

Built between 1868 and 1874 as a free school for blacks, only the basement level remains of the original two-story, wood building on a high brick basement. It was named for Robert Gould Shaw, commander of the Fifty-fourth Massachusetts regiment for free blacks during the Civil War. The regiment was morbidly defeated at Battery Wagner on Morris Island in 1863 and is depicted in the recent movie *Glory*. The building has been rehabilitated as a boys' club and day care center.

7. 25 MORRIS STREET

Morris Street Baptist Church

Een eighteen fity six, de white people ob Moyse Skreet Baptis' Chu'ch clos' deh doh, mainly 'caus' de money fuh run de chu'ch gon' low. Dey jy'n wid de Cituhdel Squay' Baptis' so deh ol' chu'ch bin turn obbuh tuh Cituhdel Squay'. Cituhdel Squay' sell de Moyse Skreet buildin' tuh uh man name H.A. Tuppuh, uh white pree'chuh who bin wid de Fus' Baptis' Chu'ch on Chu'ch Skreet. Een 1865, Fus' Baptis' laytuh ghee de Moyse Skreet Chu'ch to Reblun Jacub Laygree, who bin de pree'chuh fuh de black people. Deh call Fadduh Laygree. Reblun Tuppuh 'n 'e fadduh, 'n 'e brudduh, Jaymes Tuppuh 'stablish de fus' Sunday school fuh blacks een de Baptist chu'ch. On May nyn't eighteen sixty fy'b uh meetin' bin call at de Moyse Skreet Hous'

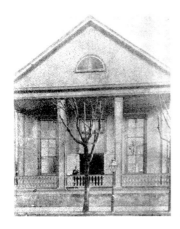

First Morris Street
Baptist Church. *Courtesy of Avery
Research Center.*

*ob Wahshup wid black membuh fum de Fus' Baptist Chu'ch, de
Wentwort' Skreet Baptist Chu'ch (now Senninary Medduhdis')
'n de Cituhdel Squay' Baptis' Chu'ch. Uh reslushun bin pas' dat
de shree chu'ch jy'n' up 'n 'dopp de Ahtical ob Fayt, de Chu'ch
Cob'nint 'n de rul' ob gob'ment ob Baptis' chu'ch. Dis meetin'
staa't de people ob de fus' black Baptis' chu'ch een Chaas'tun,
Moyse Skreet Baptis' Chu'ch. Fadduh Jaycub Laygree bin de
fus' pastuh wid sebbinty shree chaatuh membuh. De fus' sebbin
deacon ob de chu'ch bin: J. Rob'sn, J.L. Daaht, who bin de
seccun pastuh, Ned Caahtuh, Jaycub MacNeel, Fadduh Boone,
'n Fadduh Collin'. De ol' buildin' bin mek laahg' 'cus' de people
keep com'n. Dah buildin' latuh 'skroy by fire. Uh new on bin
buil' een ny'teen odd nine 'n cos' sebbinty fy'b towsen' dollar fuh
buil'. Uh fire on Febburary twenty, nineteen sixty fo' bun em*

Second Morris Street
Baptist Church. *Courtesy of Avery
Research Center.*

*down. Deh staa't uh new chu'ch yah een Maach nineteen sixty
eight 'n cost fy'b hunnud 'n sixty nine towsen dolluh fuh buil'.
Deh dedicate um een Nowembuh tirty, nyteen sixty nine.*

In 1856, the white congregation of Morris Street
Baptist Church closed its doors, mainly for financial
reasons. They joined with Citadel Square Baptist and
subsequently the Morris Street building was turned over
to Citadel. Citadel Square later sold the building to a
Mr. H.A. Tupper, a white minister associated with the
First Baptist Church on Church Street. In 1865, First
Baptist gave the Morris Street building to Reverend
Jacob Legare, who was affectionately known as Father
Legare, and the black members of First Baptist. Father

Third Morris Street
Baptist Church.
*Courtesy of Avery
Research Center.*

Legare was the worship leader for the blacks in First
Baptist. Reverend H.A. Tupper, his father and his
brother James Tupper helped establish the first Sunday
school for blacks in the Baptist Church.

On May 9, 1865, a meeting was held at the Morris
Street House of Worship with black members from
the First Baptist Church, the Wentworth Street Baptist
Church (now Centenary Methodist) and the Citadel

Square Baptist Church. A resolution was passed that united the three churches and adopted the articles of faith, the church covenant and the rules of government of Baptist churches. This meeting created the congregation of the first black Baptist church in Charleston, Morris Street Baptist Church. Father Jacob Legare became the first pastor with seventy-three charter members. The first seven deacons of the church were J. Robinson; J.L. Dart Sr., who would become the second pastor; Ned Carter; John Carter; Jacob McNeil; Father Boone; and Father Collins.

The old building had been enlarged to accommodate the growing congregation but was later destroyed by fire. In 1909 a new edifice was erected at the cost of $75,000. On February 20, 1964, the 1909 building was completely destroyed by fire. A new structure was begun in March 1968, at a cost of $569,000. The church was officially dedicated on November 30, 1969. The congregation is still strong in the development of the spiritual growth of its members and the community and continues to develop new programs to set the pace for the future.

8. 200 COMING STREET

Immaculate Conception School

Een nineteen odd fo', dem nun, de sistuh ob our Lady Ob Mahcy staa't uh school fuh 'e black Catlic student obbuh on Sheppud Skreet. De Sint Petuh school on Cy'ty Skreet bin anudduh Catlic School. Een nyteen sebbinteen, de Oblate Sistuh of Probadence, who bin in chaa'ge ob 'Maculate Cepshun 'miniskrayshun, tek obbuh de Sint Petuh school. Een nyteen tirty, wid de help ob de Di'cese 'n de Sint Kat'rin Drexel, de Oblate 'n Holy Ghost Fadduh, 'sis een de locashun ob 'Maculate 'Cepshun School to two hunnud Comin' Skreet. De school hol' fum kinnuhghaad'n shru twelve grade. 'E bin pribit school 'n deh had fuh pay money. Een nyteen sebbinty one, when dey staa't innuhgrayshun, de di'cese ob Chaa'stun reskruck de shree school een de city. All sebbin 'n eight grade go to 'Maculate school, 'n de uppuh class gon' tuh Bishup Englin' High School at two od shree Killhoun Skreet. Een nyteen sebbinty shree, de di'cese clos' 'Maculate School. Fuh many yea' de rent dah build'n out. De place now is hous' fuh ol' people. Wid all de light skin chillun deh had deh might mek you tink 'e bin school fuh high yallah chillun. 'E bin one ob de finest pribit cullud school deh had fuh cullud chillun.

In 1904, two Sisters of Charity of Our Lady of Mercy started a school on Shepard Street for black Catholic students. Saint Peter's School on Society Street was

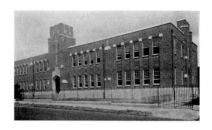

Immaculate Conception High School. *Courtesy of Avery Research Center.*

another black Catholic school. In 1917, the Oblate Sisters of Providence, who headed the Immaculate Conception administration, took over the Saint Peter's School. In 1930, with the help of the diocese and Saint Catherine Drexel, the Oblates and Holy Ghost Fathers assisted in the relocation of Immaculate Conception School to 200 Coming Street. The school included grades kindergarten through twelve. It was a private school and tuition was required. In 1971, at the onset of integration, the diocese of Charleston restructured the three parochial schools on the peninsula. All seventh and eighth graders went to ICS, and the upper classes went to Bishop England High School at 203 Calhoun Street. In 1973, the diocese closed Immaculate Conception. For many years the building was rented out. Presently, it is an affordable-housing complex for seniors.

The perception of the Immaculate Conception High School student body may suggest in the minds of some an effort to perpetuate a caste system. Many

black Charlestonians refer to ICS as "the school for light-skinned blacks." Even social clubs, such as the Pirouettes, catered to the light-complexioned girls. Dark-skinned blacks with money or a "name" were gladly accepted. Academically, Immaculate Conception High School was one of the finest black private schools in South Carolina. Most of its students went on to college and received advanced degrees in many areas of study.

9. 78 Line Street

Coards Photography

Een nyteen tirty, Coard staa't 'e pitchu tekin bidness yah. 'E bin de longis' runnin' cullud pithuh tekin' bidnes' een Chaa'stun. 'E clos' up een nyteen eighty nine. De fam'ly dem gee de khamrah 'n tings tuh Aabrey Resucch Musum.

In 1930, Coard started his photography Studio at 78 Line Street. Until its closing in 1989, it was the longest running black photography business in Charleston. His cameras and other photographic equipments are in Avery Research Center.

10. 244 PRESIDENT STREET

Burke High School

Een nyteen hunnud 'n ten, at de cornuh ob Fishburn' 'n President Skreet, Burke bin staa't. 'E fus bin staa't as de Chaa'stun Cullud 'Dustr'l School, by John L. Daaht een eighteen nihty fo'. Daaht bin uh Baptis' ministuh, knewsh pepuh publishshuh an eddycatuh 'n staa't de fus black public lyberry fuh cullud een Chaa'stun. 'E daughtuh, Susie Daaht Butluh opurat' de Daaht Lyberry at Kracke 'n Bo'ghaad Skreet, fuh cullud een Chaa'stun. Een Jannuhrery tir'd, nyteen 'lehbin, Burke open wid shree hunnud sebinty fy'b chillum 'n eight white teachuh, wid Fulup P. Mazyck fuh principul. Een nyteen, nyteen, by de changin' on de law, de pit sixteen black teachuh fuh place de eight white teachuh. Een nyteen fity fo', Burke teachuh 'n student bin jy'n up wid Aabrey Normul School.

In 1910, at the corner of Fishburne and President Streets, Burke High School was started as an offshoot of the Charleston Colored Industrial School that was founded by John L. Dart in 1894. Dart was a Baptist minister, newspaper publisher and an educator, and he started the first public library for blacks in Charleston. His daughter Susie Dart Butler operated the Dart Library at Kracke and Bogard Streets.

On January 3, 1911, Burke opened the school with 375 students, eight teachers and Philip P. Mazyck serving

as principal. In 1919, by a legislative act, sixteen black teachers replaced the eight, all-white faculty members. In 1921, after the death of J.E. Burke, it was renamed the Burke Industrial High School. For many years Burke housed grades six through eleven. In 1939, with William Henry Grayson Jr. as principal, the school expanded its curriculum to include a three-track program: basic curriculum, industrial and trade curriculum and a college-prep program. Grayson stressed that the teachers should advance their educations to include master's degrees. In 1954, Burke's faculty and student body were merged with Avery Normal School.

11. 135 CANNON STREET

FIRST SITE OF MCCLENNAN–BANKS HOSPITAL

Hospital and Training School for Black Nurses

De build'n wha' bin yah bin once de Islin'tn Manuh, uh pos'-Rebbuhlushunerry buildin' buil' een eighteen hunnud by Henry Ellisun. Een eighteen ni'ty sebbin deh mek um hospital fuh trainin' cullud nus'. Deh call um de Cannun Skreet Hospitul. Een nineteen fi'ty fo' deh tek de buildin' down 'n moob obbuh tuh twenty fy'b Cout'ny Dri'b. De hospital staa't yah een eighteen ni'ty nine by Doctuh A.C. MuhKlennun 'n Doctuh Lucy Youz Brown, de fus'

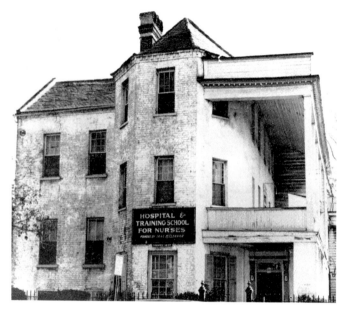

McClennan-Banks Hospital. *Courtesy of Avery Research Center.*

black ummun doctuh een Sous' Kahlina. Anna Banks bin de Dyrectuh of Nussin. Dah build'n gon' now but a new one don' buil' yah 'n deh keep de nayme, "MuhKlennun-Banks."

The hospital was once Islington Manor, a post-Revolutionary dwelling house, built in 1800 by Henry Ellison. In 1897, it was converted into a hospital and

training school for black nurses and was called the Cannon Street Hospital. In 1954, the building was demolished and was replaced with the new McClennan-Banks Hospital at 25 Courtney Drive.

The hospital was established in 1899 by Dr. A.C. McClennan and Dr. Lucy Hughes Brown, South Carolina's first black female physician. Anna Banks was the director of nursing. The hospital remained in operation until the early 1980s, when it became a part of Charleston Memorial Hospital, now Medical University of South Carolina. The building was demolished and a new building was erected with the name "McClennan-Banks."

12. SPRING AND HAGOOD AVENUE

The Saint James Hotel

Een nyteen fity one, Edward, George, James and Henry Washin'tn, staa't buildin' on de St. Jaymes Hotel. Irly de next yea' 'e open as de fus' full-serbice hotel een Chaa'stun fuh culludd. 'E bin uh 'pressive two story buildin' wid twenty gues' room. Dey steady de head 'bout buildin' de hotel 'cause een nynteen tirty sebbin, deh had uh good ressurunt obbuh on State Skreet. Den two yea' latuh dey moob um tuh Queen Skreet. Een nyteen forty ny'n deh moob obbuh tuh Spring Skreet. 'E bin one ob de laahgis colored ressurunt ob de

time. Wisituhs comin' tuh Chaa'stun had tuh stay een pribit home, but now deh kin stay een hotel. Deh had udduh tings at dat hotel lyke de Ballroom, De 'Zaylyuh Room, 'n de Limbo Room. Some famous people wha' stay de bin: Duke Ellin'tn, Fat Domino, Count Basie, Hank Aarun, 'n Jaymes Brown. Een de saym block fum President Skreet on down bin plenny colored own bidnes'. Deh had de J 'n P Khaafay, owned by Esau Jenkins, uh cibil right wukkuh man, 'n de Budlan' Night Club. In nyteen sebbinty tings staa't fuh go down 'cause de colored kin go tuh de white people hotel. Een nynteen sebbinty eight deh had tuh close deh door. McDonald hab uh ressurunt deh now.

In September 1951, Edward, George, James and Henry Washington started construction of the Saint James Hotel. Early the next year it opened as the first full-service hotel in Charleston for blacks. It was an impressive two-story structure with twenty guest rooms. Building a hotel was prompted by the success of the family restaurant that was opened in 1937 on State Street. Two years later it moved to Queen Street. In 1949 it was relocated to Spring Street. The restaurant was described as the largest black-owned restaurant at that time. The guests at the hotel were now able to come directly next door for their meals. Besides lodging, the hotel boasted the Saint James Ballroom, the Azalea Room and the ever-popular Limbo Room. The hotel provided lodging for those who normally would have to stay in private homes. A few of the famous guests who

Hotel James. *Courtesy of Avery Research Center.*

stayed there were Duke Ellington, Fats Domino, Count Basie, Hank Aaron and James Brown.

In the same block of the Saint James hotel, from President Street on down, were many black-owned businesses. Most notable were the J and P Café, which was owned by civil rights activist Esau Jenkins, a Johns Island native, and the Birdland Night Club.

In the 1970s, integration brought the hotel to an end. Now that blacks were able to stay at hotels that had once banned them, in 1978 the declining business forced the Saint James Hotel to close its doors. A McDonald's restaurant now occupies the site.

13. Country Club Road and Folly Road

McLeod Plantation

Just West of Charleston, across the Ashley River Bridge and less than ten minutes from downtown Charleston, is McLeod Plantation, one of the most important examples of African American history in the Southeast.

In the year 1671, the Council of Province ordered a town to be established on James Island. McLeod Plantation (not called that at that time) became a part of James Island around 1696. The property was first owned by Morris Morgan in 1696 and included about 617 acres. There was no formal building on the property except for a few slave quarters. Dual residences existed, and many plantation owners had homes elsewhere, usually in the city. From the colonial period and well into the twentieth century, most of James Island consisted of blacks. Around 1720, Saint Andrew's Parish records reported around 215 white taxpayers and nearly 2,500 slaves. The slaves were left to oversee and cultivate the property. One of the main activities at the plantation was the raising of beef, which gave this plantation an advantage at a time when everyone else was struggling exclusively with cotton. The slaves from the Gambia River region were expert horsemen and cattle herders. They were America's first cowboys. Indigo was also

a major crop at this plantation, but the process of extracting the dye from the plant caused the slaves to develop cancer. The rivers were the major modes of transportation, and these Africans were highly prized for their skills as boatmen. The job as a boatman gave a measure of independence to a slave.

In 1703, the 617-acre property became a royal grant to Captain David Davis, and in 1706, Davis sold the land to William Wilkins. In 1741, Wilkins sold the property to Samuel Peronneau. Peronneau was the only one to cultivate the property. None of the previous owners, including Peronneau, ever lived on the property, but they did have slaves living there. In 1770, 250 acres were either sold or given to Edward Lightwood II, Peronneau's son-in-law. It was Lightwood who built the first main house and outbuildings. The house was approached from the south by an oak alley that extended northward to Wappo Creek.

Lightwood was a "broker" in slave trading and owned fifty-three slaves. Lightwood's daughter married William McKenzie Parker I in 1796. When Parker's mother-in-law died, he purchased the estate. Parker was involved in the slave trade industry and owned several vessels. Like Peronneau and Lightwood, Parker also worked the plantation.

In 1851, the plantation was sold to William Wallace McLeod. By this time, the property had increased to

McLeod Plantation house.

914 acres of highland and 779 acres of marsh. McLeod built the present house around 1854–1856. Exactly what happened to the Lightwood house is unknown. Speculations are that it was either destroyed or torn down. Around 1860, McLeod owned approximately seventy-four slaves and twenty-three slave cabins that were located around the plantation. The five remaining twenty- by twelve-foot wooden slave cabins, the dairy and the kitchen building are believed to date from the Lightwood/Parker period (1770–1850). The old slave bell, used to call in the slaves from the fields, still hangs from the giant oak tree near the "big" house.

Slave quarters at McLeod Plantation.

William Wallace McLeod served in the Civil War and moved his family to Greenwood, South Carolina. He left Steven Forrest, a slave, in charge of the plantation. McLeod died in the war in 1864. Shortly after, Mrs. McLeod died, leaving a boy still in his teens and two young girls as owners of the plantation. During the war, the house fell to the Federals. The house was used as a Federal headquarters and a hospital for the black units of the Fifty-fourth and Fifty-fifth Massachusetts regiments. After the war, the house was the headquarters

for the Freedmen's Bureau. Freed slaves from all over the island pitched pine borough shelters and camped on the plantation in order to be within easy reach of their free rations and their "forty acres and a mule." Unlike other parts of the South, tenancy was preferred to sharecropping. It gave the black farmers freedom from white exploitation and the hope of accumulating money to purchase their land. This plan proved to be very successful for blacks well into the years after emancipation.

McLeod's son arrived back at the plantation in 1879, after Congress failed to pass Sherman's Field Order No. 15. It was said that the young McLeod was forced to apply for an escort of Union soldiers to lead him through the crowd of insolent Negroes who thronged around the house.

After greedy carpetbaggers dismantled the Freedmen's Bureau, black families continued to maintain quarters in each room of the house. They took possessions and used the house as they chose, with no regard for owners or property. McLeod later was able to establish ownership and dispose of the blacks. In 1895, Dr. Bert J. Wilder, who had been a surgeon for the Union army, visited Charleston and told McLeod that the drawing room of the house had served as his operating room for the black soldiers of the Fifty-fourth and Fifty-fifth Massachusetts regiments. Those who died were buried

McLeod Plantation slave bell.

in the slave cemetery (a site on the hill to the left after crossing the James Island Bridge).

Willis Ellis McLeod, who was born in 1885, became owner of the property in 1918 and lived there until his death, in 1990, at the age of 105. Willis Ellis McLeod continued to sell and rent properties to blacks long after the war. The slave quarters date back to the Lightwood/ Parker period and are some of the oldest wooden slave quarters in the South. Blacks continued to occupy these slave quarters until around 1990.

ABOUT THE AUTHOR

Alphonso Brown was born and reared in Rantowles, South Carolina, a rural area about twelve miles south of Charleston. He graduated from Baptist Hill High School and received a bachelor's degree in music from South Carolina State University and a master's degree from Southern Illinois University. He pursued other graduate studies in music at the University of South Carolina, Charleston University and the Citadel.

Mr. Brown is a licensed tour guide for the City of Charleston and owns and operates Gullah Tours. He is a lecturer on the Gullah language and black history of Charleston. He has given lectures and Gullah presentations for students from North Carolina A&T College, National Association of Substance and Drug Abuse Commission,

Charleston Nurses Association, the Medical University Minority Program, the 1993 Annual Meeting of the Seventh Episcopal District of the South Carolina AME Church Lay Organization, the University of College Designers Association, Delta Sigma Theta sorority of Chapel Hill, North Carolina, Bell South and many other organizations. He has been a guest on the talk show *Question of the Day*, KQXL in Baton Rouge, Louisiana, Michael Feldman's radio talk show and has made numerous radio and television appearances.

Mr. Brown's Gullah Tours was featured in the May 1993 issue of the *Charleston Magazine*, in the February 1995 edition of *Southern Living* magazine and the January 1996 edition of *Reader's Digest*, as well as in the *Boston Globe, New York Times* and Charles Kuralt's bestseller *America*. It was also featured on Bert Wolf's television special of Charleston, *Southern Living Presents* on Turner South Television Network, South Carolina PBS specials and *B. Smith with Style*. He is a recipient of the very prestigious "Three Sisters Award." His website is www.gullahtours.com.

Mr. Brown is a retired band director from the Charleston County School District, where he worked at Rivers High/ Middle School for many years. He and his wife Laquines are the proud parents of three sons, Howard, Terrence and Joel, and three daughters-in-law. They have five grandchildren.

If you enjoyed this book, you may also enjoy
Damon L. Fordham's

Voices of Black South Carolina

$19.99 • 160 pages • over 20 images • ISBN 978-1-59629-611-4

Dᴵᴰ ʏᴏᴜ ᴋɴᴏᴡ that eighty-eight years before Rosa Parks's historic protest, a courageous black woman in Charleston kept her seat on a segregated streetcar? What about Robert Smalls, who steered a Confederate warship into Union waters, freeing himself and some of his family, and later served in the South Carolina state legislature? In this inspiring collection, historian Damon L. Fordham relates story after story of notable black South Carolinians, many of whose contributions to the state's history have not been brought to light until now.

Visit us at
www.historypress.net